D0555271

IMAGES
of America

WATERLOO

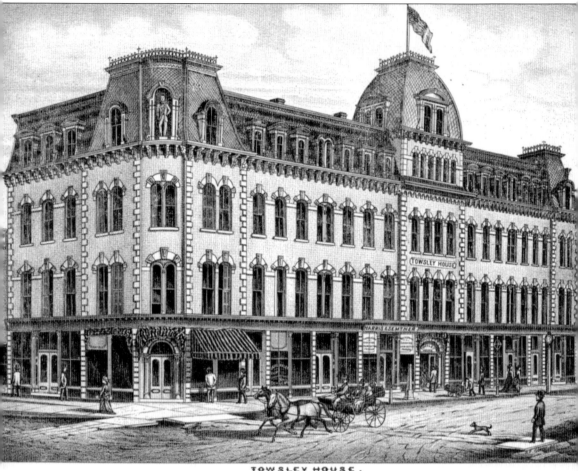

TOWSLEY HOUSE,
THIS HOTEL IS FIRST CLASS, IS SITUATED NEAR THE RAIL ROAD, & FURNISHED WITH ALL THE MODERN IMPROVEMENTS.

THE ORIGINAL TOWSLEY HOUSE. In December 1869, Alonzo Towsley proposed to build this hotel on the site of the old Eagle Tavern. The Towsley House was built at an approximate cost of $100,000. J.R. Thomas was the architect and designed the four-story building with a basement. It would be constructed of brick with cut-stone pillars and supports. The arches and graceful columns of Grecian architecture were stunning. The Towsley House was the finest and best hotel building in western New York for years. The rooms, the food, and the service were excellent. (Courtesy of the Waterloo Library and Historical Society.)

ON THE COVER: This is an early-1900s photograph of a barge on the Cayuga-Seneca River in Waterloo, New York. (Courtesy of the Waterloo Library and Historical Society.)

IMAGES
of America

WATERLOO

Bonnie J. Breese

ARCADIA
PUBLISHING

Copyright © 2016 by Bonnie J. Breese
ISBN 978-1-4671-2181-1

Published by Arcadia Publishing
Charleston, South Carolina

Printed in the United States of America

Library of Congress Control Number: 2013952068

For all general information, please contact Arcadia Publishing:
Telephone 843-853-2070
Fax 843-853-0044
E-mail sales@arcadiapublishing.com
For customer service and orders:
Toll-Free 1-888-313-2665

Visit us on the Internet at www.arcadiapublishing.com

This book is dedicated to the citizens of Waterloo, New York, who in 1866 held the first complete Memorial Day observance, to the untiring efforts of those citizens who enabled Waterloo to be rightfully recognized as the birthplace of Memorial Day, and to the people that today work to make Memorial Day what it should be, a time to remember those who gave their lives to keep us free.

CONTENTS

ACKNOWLEDGMENTS

All of the images in this book, unless otherwise noted, appear courtesy of the Waterloo Library and Historical Society. I want to thank them for allowing me access to and use of their collection of photographs and information to complete this book.

I also want to give special thanks to the following individuals:

Cynthia Parks-Shiels, executive director of the Waterloo Library and Historical Society.

Blaine M. Elkie, town of Fayette historian, for sharing his personal collection of photographs and allowing me use of these and for sharing his knowledge of Waterloo, as the historian at the National Memorial Day Museum in Waterloo.

Diane Lerch Kurtz, for allowing me use of her personal collection of Waterloo photographs and postcards.

Charles E. Breese, my husband, for his encouragement and guidance throughout this project.

Lily Watkins, editor at Arcadia Publishing, for her support and guidance through the tough parts of developing this book.

BIBLIOGRAPHY

Becker, John E. *A History of the Village of Waterloo, New York and Thesaurus of Related Facts.* Waterloo, NY: Waterloo Library and Historical Society, 1949.

"Grip's" Historical Souvenir of Waterloo, N.Y. 1903

"History of Seneca Co. New York, 1786–1876" with Illustrations Descriptive of Its Scenery, Palatial Residences, Public Buildings, Fine Blocks and Important Manufactories, From Original Sketches by Artists of the Highest Ability. Philadelphia, PA: J.B. Lippincott & Co., 1876; Ovid, NY: W.E. Morrison & Co., 1976.

www.CO.Seneca.NY.US

INTRODUCTION

The idea of a Decoration Day or Memorial Day started in Waterloo in 1865, with the first real celebration being in 1866. In Waterloo, the tradition of decorating graves, having parades, and draping homes and businesses with flags and buntings started in 1866 and has continued every year since. Memorial Day in May 2016 marks the 150th year of the celebration.

The development of the Seneca River/Barge Canal was the main reason for the growth and prosperity that Waterloo enjoyed during the late 1800s and early 1900s. The village developed not only the industrial portion of Waterloo but also the commercial and residential portions along this river. It has turned into a beautifully scenic waterway enjoyed by numerous boaters.

The Seneca River enabled many industries to thrive. The waterway provided much-needed transportation of manufactured goods out of the village and to major cities around the country. Waterloo manufactured numerous products, everything from automobiles to woolen products, organs and pianos, and wheels. The river proved to be an inexpensive way to transport goods.

With major industries in Waterloo, there became the need for small products and services, many needed for day to day life. Small businesses started throughout the village, providing hotel rooms, restaurants, food, clothing, iron and metal products, bricks and building materials, shoes and boots, candy and confections, bakeries, drugstores, theater and entertainment, tailors, and barbershops. The village continued to grow.

Growth in the private sector required growth in the public sector. The people of Waterloo built some of the most beautiful churches, schools, and parks in the area. Three of the churches, St. Paul's Episcopal, the First Presbyterian Church, and the United Methodist Church, are in the National Register of Historic Places. Education was extremely important in the development of Waterloo, with both public and private schools in the early years of development.

As the population grew with the growth of industry, there became a need for more housing. Many large beautiful homes were built in those early years of growth and are as beautiful today as they were when they were built. Different styles of architecture, including Italianate, Federal, Queen Anne, and Greek Revival, were used both in the building of homes and the public buildings.

The population of Waterloo grew from about 300 in 1820 to 3,400 in 1860 to 5,400 in 1960. Many new ideas came from the citizens of Waterloo. There were inventors, like Wellington Porter and Barney Oldfield. There were political movements driven by people like Mary Ann M'Clintock and Jane Hunt. There were sports professionals like Tom Coughlin and Louise Scherbyn.

The citizens that built Waterloo in the early years did so with a sense of pride. In 1875, a small group of citizens gathered together, some 85 years after the first settlement of Waterloo, to form an association with the single intent to perpetuate the history of the village. They wanted something permanent and something useful. They formed what eventually became the Waterloo Library and Historical Society. They developed a certificate specifying its objectives: "The establishing, creating and maintaining a library and purchasing and preserving literary, historical, geological, genealogical, and scientific papers, pamphlets, works, books, mementos, maps, charts, surveys,

specimens, objects, curiosities, mechanisms of various kinds, picture and general information, knowledge and facts in any form having connection with either of the above named objects." This was the beginning of the development of the Waterloo Library and Historical Society.

Over the years, much of the original material that built this library has deteriorated; some has been mishandled or simply tossed away. It is the sincere hope that future generations will look to preserve as much of the history of Waterloo as possible.

One

Birthplace of Memorial Day

The custom of celebrating Memorial Day (originally Decoration Day) with parades, flag buntings draped on buildings, handmade evergreen wreaths, floral crosses, bouquets placed on the grave of each fallen hero, and the delivery of speeches with words of tribute to our war dead originated in Waterloo, New York.

Henry C. Wells is credited with the idea in late 1865, and Gen. John B. Murray (the Father of Decoration Day) is credited with carrying out the idea with the first Decoration Day celebration on May 5, 1866. On May 5, 1868, the second anniversary of Decoration Day, Gen. John A. Logan issued an order that officially set aside May 30 as Decoration Day.

The idea of Decoration Day appealed to Americans, and the practice of decorating soldiers' graves spread quickly to every part of the North and soon to every state. It is now celebrated every year, and few stop to think where it originated. The term Decoration Day was changed to Memorial Day at the request of the Grand Army of the Republic. In 1965, the Waterloo Memorial Day Centennial Committee worked to obtain national recognition of the fact that Waterloo is the birthplace of Memorial Day.

A joint resolution passed by the US Congress and a proclamation by Pres. Lyndon B. Johnson in May 1966 officially recognized Waterloo as the birthplace of Memorial Day.

The citizens of Waterloo continue to work to enhance the celebration of Memorial Day. On September 20, 2008, the American Civil War Memorial was dedicated to honor the fallen of the first Memorial Day in 1866. The memorial was designed by sculptor Pietro del Fabro of New Jersey. It is located on Lock Island along the Cayuga-Seneca Canal, part of the Erie Canal System. The North South Cenotaph is constructed of stones sent from each of the 36 states in existence at the end of the war. There is also a Women's Cenotaph, which pays tribute to all the women of the Civil War.

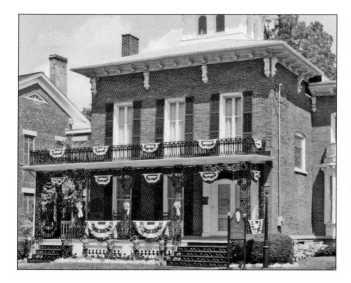

NATIONAL MEMORIAL DAY MUSEUM. This is the same Waterloo mansion that saw the first Memorial Day in 1866 and has now become the official headquarters of the Memorial Day Committee and the National Memorial Day Museum. It is located at 35 East Main Street, Waterloo, New York. By presidential proclamation, in May 1966 Waterloo was recognized as the birthplace of Memorial Day. The museum houses artifacts of the first Memorial Day and the Civil War era.

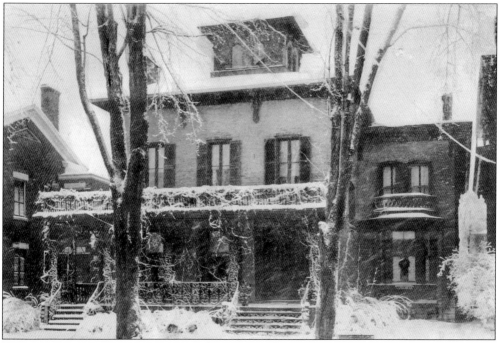

WATERLOO MEMORIAL DAY MUSEUM. The museum's home is now this mansion at 35 East Main Street, which was built in 1830 by Moses Serverance and sold to William H. Burton in 1853. Burton sold to Dr. George A. Bellows in 1890, and it was passed to his son Dr. Lester W. Bellows in 1910. This photograph was taken in 1930, before the building was sold in 1935 to become a rooming house. It suffered considerable deterioration until 1965, when it was purchased for $1 for the Waterloo Memorial Day Museum.

HENRY CARTER WELLS. Wells (1821–1868) was a married father of two and a local pharmacist, fireman, and fire chief, as well as the founder of Memorial Day (originally known as Decoration Day). In the summer of 1865, after the Civil War had come to an end, Wells proposed the idea of a celebration to pay homage to those soldiers who had given their lives for the cause. In recognition of their sacrifice, he suggested setting aside a day in May to place flowers on their graves.

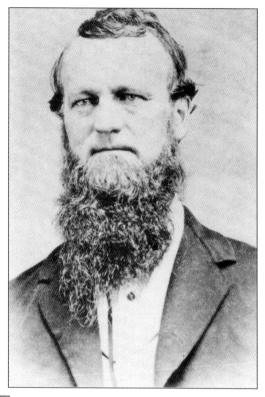

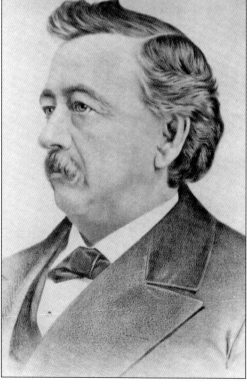

GEN. JOHN B. MURRAY. Gen. John B. Murray instituted Decoration Day, carrying out the idea of Henry C. Wells on May 5, 1866. Murray was county clerk and decided to close all businesses in town in observance of the day honoring the heroic dead. Wells has been given credit for the idea and Murray the credit for the execution of the idea.

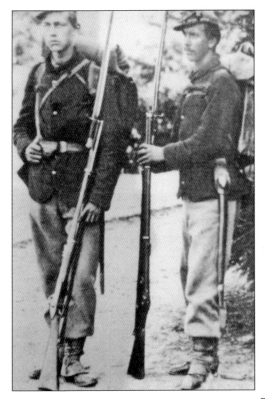

UNION SOLDIERS. Union soldiers came from "free states," which prohibited slavery before the Civil War. The Union included the states of Maine, New York, New Hampshire, Vermont, Massachusetts, Connecticut, Rhode Island, Pennsylvania, New Jersey, Ohio, Indiana, Illinois, Kansas, Michigan, Wisconsin, Minnesota, Iowa, California, Nevada, and Oregon. Abraham Lincoln was their president. Five border states (Delaware, Kentucky, Maryland, Missouri, and West Virginia) generally supported abolition but included both free areas and some slave owner areas. These five states formed the border between the Union and the Confederacy.

CONFEDERATE SOLDIERS. The Confederacy was represented by soldiers from states south of the border states. The original seven were South Carolina, Mississippi, Florida, Alabama, Georgia, Louisiana, and Texas. Virginia, Arkansas, North Carolina, and Tennessee soon followed. Missouri and Kentucky joined in the fall of 1861. Jefferson Davis was their president.

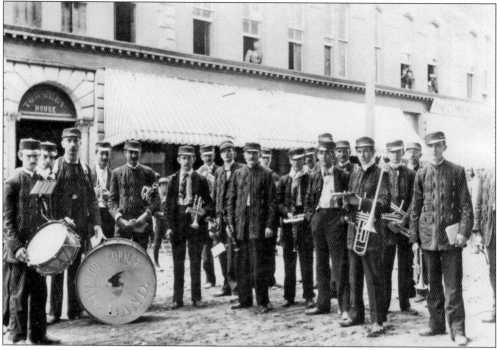

WATERLOO CORNET BAND IN THE 1870s. Although there are no surviving photographs of the celebrations held in 1866 and the years to follow, the Waterloo Cornet Band would have participated in the parade and celebration of the day. The band is pictured here in full uniform in Waterloo at the September 1878 reunion of the 148th Regiment, New York Volunteer Infantry.

EAST MAIN STREET. This parade is marching east along East Main Street at the corner of Virginia Street on the right and Washington Street on the left. The photograph was taken while standing in front of the Semtner Block. In the foreground one can see the ornamental five cluster lamps, which were placed on each side of Main Street 100 feet apart and on Virginia Street north to Williams Street in 1913 to provide all night service by the Central New York Gas and Electric Company. The post office is under construction in its present location on the left behind the construction wall.

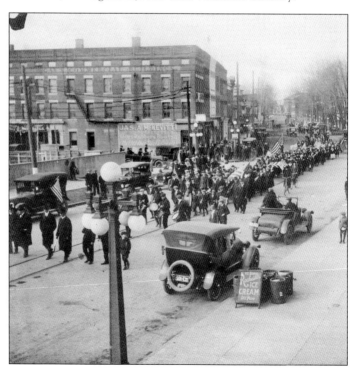

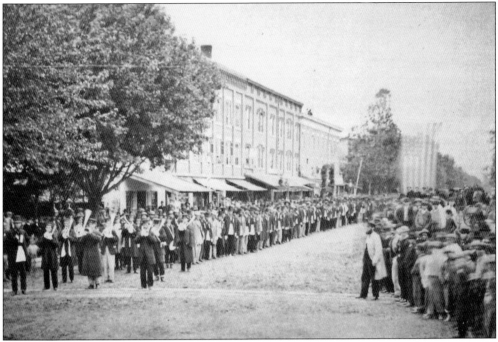

WEST MAIN STREET. The Cornet Band plays at a gathering of numerous citizens along West Main Street in the late 1800s. The three-story brick building known as the Commercial Block is on the left, and an American flag is hanging in the center of West Main Street looking east.

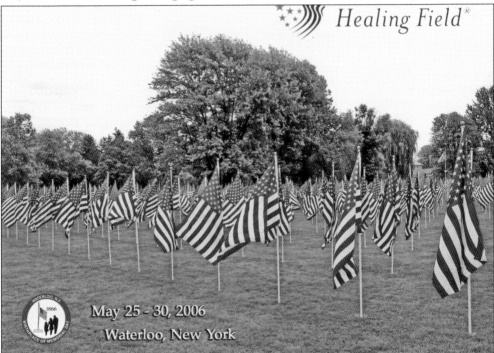

Healing Field®

May 25 - 30, 2006
Waterloo, New York

HEALING FIELD. In addition to the parade, another Waterloo tradition is observed at Healing Field, where flags are placed in memory of loved ones who have served the country.

Two

THE SENECA RIVER/ BARGE CANAL

Waterloo's growth and prosperity in the 19th century was due to the numerous industries that took advantage of the waterpower and the ability to transport on the Seneca River. The village owes its very existence to the riverside location. The Seneca River originally forked into north and south channels at Waterloo. Since the late 1700s, the river has undergone a series of changes.

In 1792, Samuel Bear, with help from the Cayuga Indians, began digging his millrace. A race is a British term used to describe a man-made channel used to move or reroute water. The Old Bear Dam was built across the largest part, the south fork of the river. He dug a race four feet deep and about 20 feet wide, from above the dam to the mill. In later years, he dug an extension to the lower sawmill and the Oil Mill near River and Distillery Streets. This race has always been known as Bear Race.

In the early 1800s, Elisha Williams constructed a race along the north branch of the river east to the woolen mills, creating waterpower on his land. Soon after, the Williams Race was incorporated in the Seneca Lock Navigation Company's canal between Seneca and Cayuga Lakes. This canal was started in 1813 and opened to traffic in 1818.

The Cayuga and Seneca Canal was started in 1826, completed in 1828, and provided the waterpower and transportation needs for Waterloo for over 80 years. A towpath was constructed along the canal to enable horses or mules to easily tow the barges previously towed by man. The section passing through Waterloo contained two locks. It was enlarged in 1836 and underwent periodic changes.

The New York State Barge Canal System was devised in 1913 to bring the aging system up to date. It followed the southern channel of the Seneca River. Construction began in 1913 and was completed in 1916. It has one lock in Waterloo, Lock No. 4, and about a 15-foot drop. The lock gates are still controlled by the original machinery in the powerhouse.

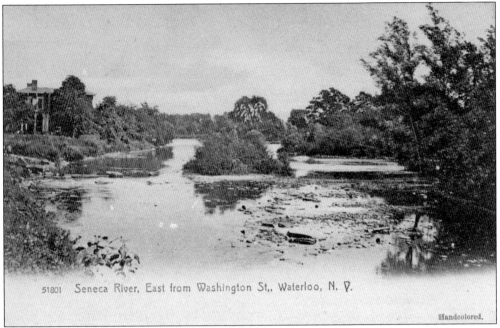

51801 Seneca River, East from Washington St,, Waterloo, N. Y.

Handcolored.

SENECA RIVER. This is a view of the Seneca River looking east from the Washington Street Bridge. There were a number of small islands located in the river and a few larger islands.

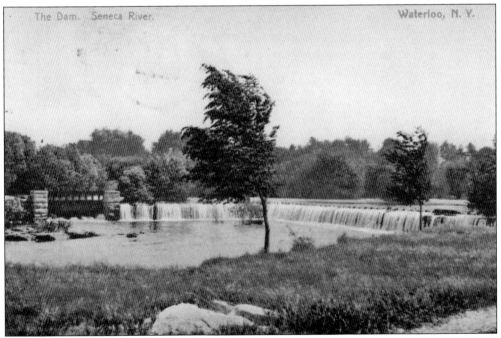

The Dam. Seneca River. Waterloo, N. Y.

THE DAM IN THE SENECA RIVER. This dam was completed in 1896 by Barlow, Martin & Company. The dam was 11 feet high, with water gates constructed in the wall to allow for the flow of water to be controlled in the interest of navigation on the canal and the mill owners. (Courtesy of Diane Lerch Kurtz.)

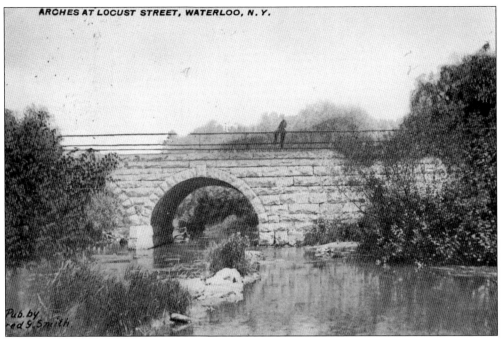

Pub. by
red S. Smith.

ARCHES OVER THE RIVER. These arches, made from Waterloo limestone and cement, form the bridge over the Seneca River at Locust Street. Featured in this postcard from 1896, the bridge was constructed by contractor John Van Riper at a cost of $3,700. (Courtesy of Diane Lerch Kurtz.)

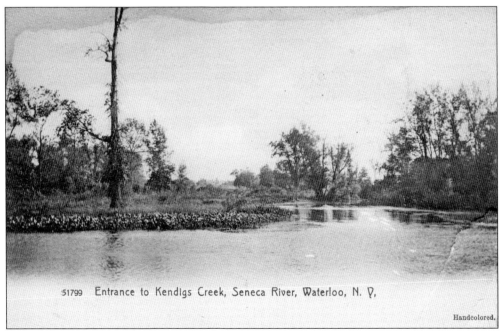

51799 Entrance to Kendigs Creek, Seneca River, Waterloo, N. Y,

Handcolored.

KENDIG'S CREEK. This is an early view of the entrance to Kendig's Creek off the Seneca River. This creek, just west of the village, has always been an abundant fishing creek. (Courtesy of Diane Lerch Kurtz.)

17

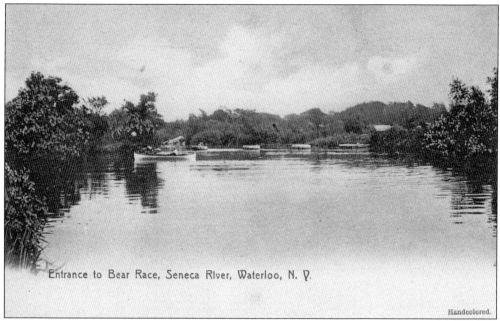

Entrance to Bear Race, Seneca River, Waterloo, N. Y.

Handcolored.

BEAR RACE. In 1888, the State of New York authorized the improvements to Bear Race by extending the canal system through the Bear Race to Washington Street. The plan was to deepen the race and make it 35 feet wider. Businesses on the north side of the race filed a lawsuit to stop the widening of the waterway. The Act of 1888 provided for the enlargement of the race to restore water to the southside owners, which through the years had been diverted to the northside owners. It was not until 1896 that the enlargement was completed, more than 100 years after the original race was constructed. (Courtesy of Blaine Elkie.)

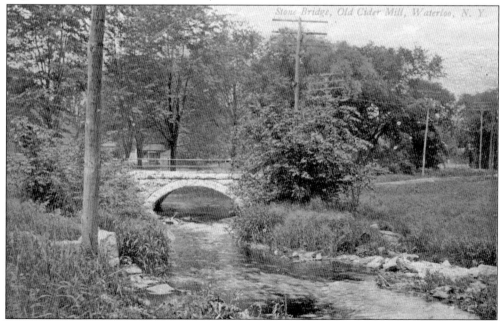

Stone Bridge, Old Cider Mill, Waterloo, N. Y.

HUFF STREET. This bridge over Lower Bear Race near River Street was constructed in July 1883. The Old Cider Mill is in the background.

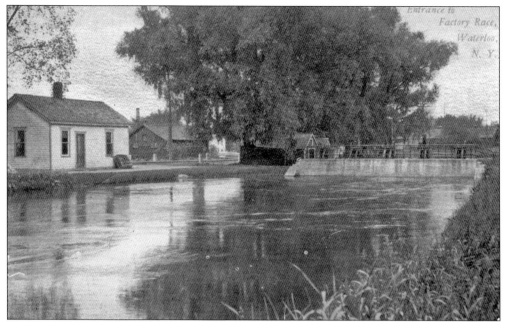

FACTORY RACE. This channel, Factory Race, was especially built off the Seneca River to lead water to the mills to be used as waterpower for flour mills, sawmills, and woolen mills.

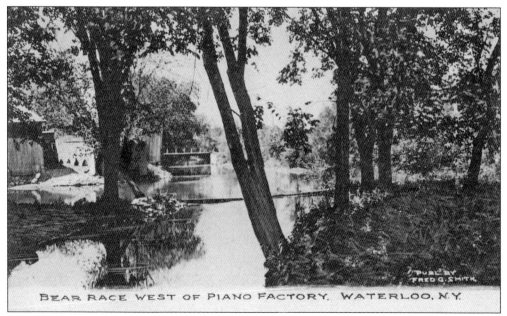

BEAR RACE. Samuel Bear, with his cousins John and Ephraim Bear, three millers from Pennsylvania, Casper, John, and George Yost, with the help of the Indians, dug Bear Race in 1793. It was 4 feet deep and 20 feet wide. Samuel Bear was the first to use the river for power. It was enlarged in 1888 and again in the early 1900s. (Courtesy of Blaine Elkie.)

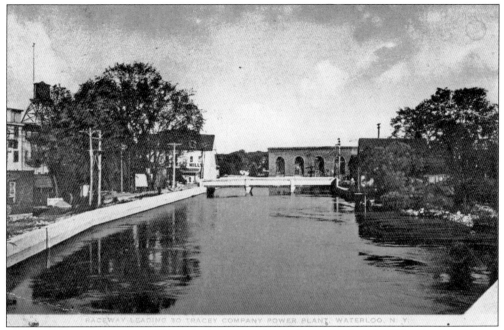

TRACEY COMPANY RACEWAY. When the barge canal was about completed in Waterloo, the Tracey Development Company constructed a modern electricity-generating plant and dug this raceway leading to the Tracey Power Plant ahead (with the arched windows). May 28, 1915, was the first day of operation for the Tracey Power Company. The men working for Tracey Power Company worked 10-hour shifts for 20¢ an hour. (Courtesy of Diane Lerch Kurtz.)

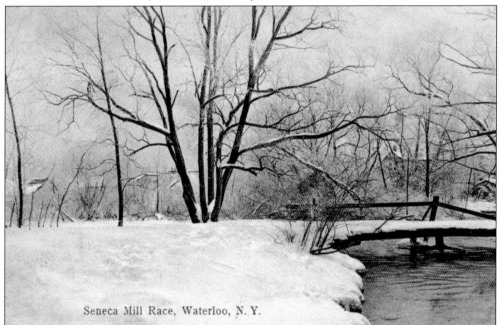

SENECA MILLRACE. This is a picturesque winter view of the Seneca Mill Race leading to the Seneca County Saw and the Seneca County Flour Mills, located west of Washington Street. (Courtesy Diane Lerch Kurtz.)

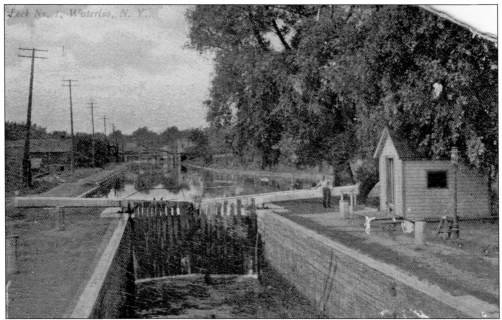

Lock No. 1. This hand-operated lock was the first of four locks located south of the woolen mills on the Seneca Canal. The Cayuga and Seneca Canal was completed in November 1828 with 11 locks.

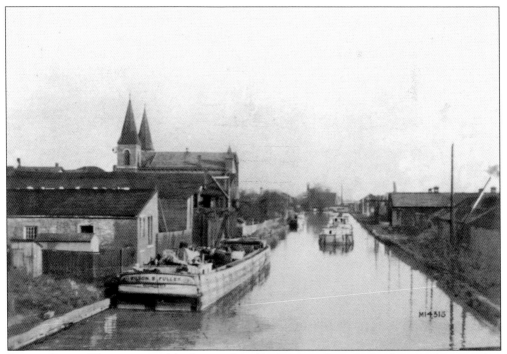

Seneca Canal. This is a view of the Seneca Canal looking east from the Washington Street Bridge. The canal was built to handle the larger barges like the *Wilson S. Fuller*, pictured on the left.

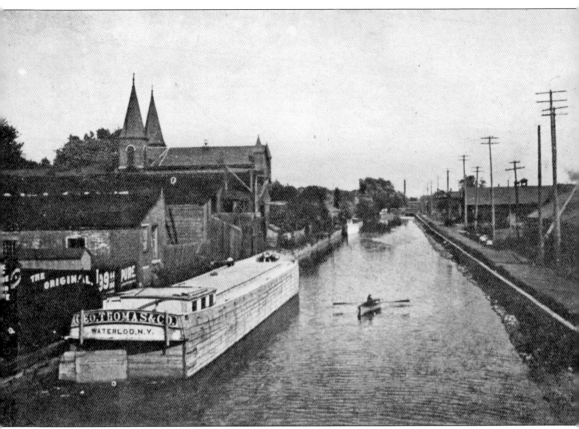

BARGE ON SENECA CANAL. Pictured here is a George Thomas and Company coal barge on the Seneca Canal east of Virginia/Washington Street Bridge.

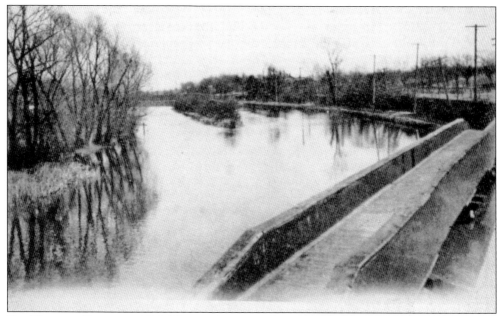

The Towpath Bridge in 1912. The new barge canal was intended for larger boats, towed by tugs or propelled by steam or oil. On the old canal, the towpath was very important, because most boats were towed by mules or horses. They walked along the towpath, pulling the boats with ropes or cables. The towpath through Waterloo was on the south side of the canal from east of the Gorham Street Bridge, past the two locks, to the Locust Street Bridge, where the mules crossed the bridge to the north side. From there, the towpath continued to Geneva.

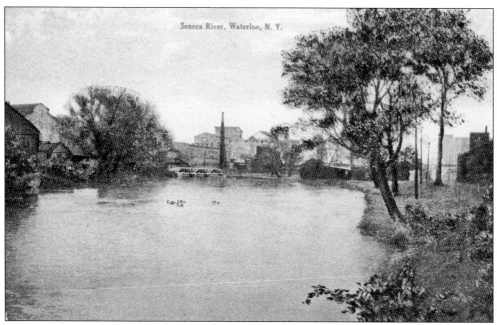

Manufacturing on the River. The Seneca River appears in the background of many of the manufacturing sites in Waterloo, including the woolen mills, the flour mills, the distilleries, the malt houses, piano and organ manufactories, carriage manufactories, and many more.

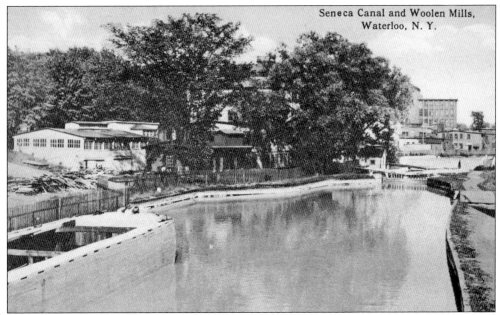

Seneca Canal and Woolen Mills, Waterloo, N. Y.

MILLS. This view looks east, with the Seneca Canal in the foreground and the Waterloo Woolen Mill in the background on the right. In 1854, the state approved the enlargement of the canal to the general dimensions of 70 feet wide and seven feet deep. This was later changed from Waterloo to Seneca Lake in Geneva to be 60 feet wide and nine feet deep. (Courtesy of Diane Lerch Kurtz.)

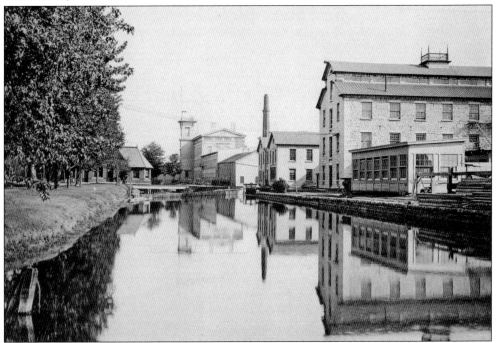

WOOLEN MILLS. Waterloo Woolen Mill is on the right looking west on the Seneca Canal. This is the dye house and the East Mill. In 1878, the Waterloo Woolen Mill was the main support of the village of Waterloo. (Courtesy of Blaine Elkie.)

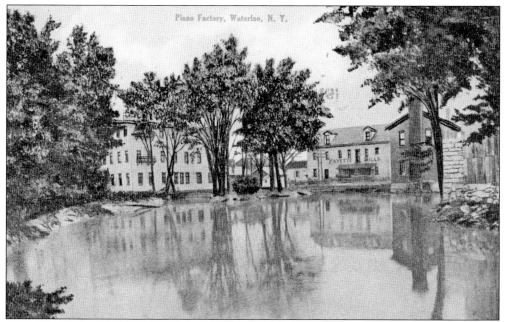

FACTORIES ON THE RIVER. The building pictured here on the left is the new three-story frame piano-manufacturing facility built in by Welling B. Lawrence after the March 1897 fire, which destroyed the original factory. It is located south of the organ company plant on Washington Street and was in operation in late June 1897. On the right is the Fayette Mill. (Courtesy of Diane Lerch Kurtz.)

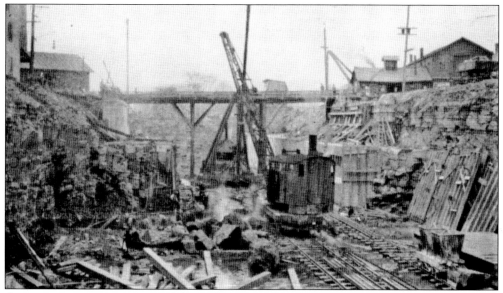

CONSTRUCTION OF THE LOCKS. Elisha Williams was the first to make improvements to the Seneca River by constructing a hydraulic lock for waterpower in Waterloo. Construction on the nine-mile portion of the Seneca Cayuga Canal began in 1813. This portion was completed in 1821. In 1825, construction of the canal from Geneva to a junction with the Erie Canal at Montezuma was authorized. This 21-mile section was opened to the public in 1828. This image shows the reconstruction of the locks in Waterloo in 1913–1914.

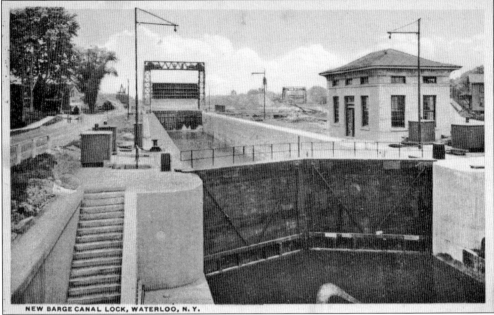

NEW BARGE CANAL LOCK, WATERLOO, N. Y.

CONSTRUCTION COMPLETE. In 1909, approval was granted to enlarge the canal to a 12-foot depth, with walls of concrete and locks with steel gates that would be powered by electricity. This would allow for barges to pass with more than 30-times capacity of the first canal barges in 1828. The increased capacity and the abolishing of canal tolls would reduce transportation costs considerably and allow shipment by barge to be more competitive with railroads. This c. 1921 image of Lock No. 4 in Waterloo shows this new construction.

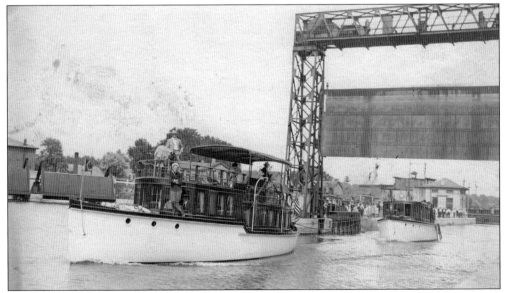

STEEL GATES. Lock No. 4, like the others on the Seneca Cayuga Canal, was originally fitted with timber gates. Those were replaced by steel gates, fabricated in the Syracuse Canal Shops. This image shows the passage of the first boat after the installation of the steel gates in 1940. These gates were operated by electricity. The guard gate at the top of the lock protects the lock and permits maintenance. The lock was refurbished again in 1984.

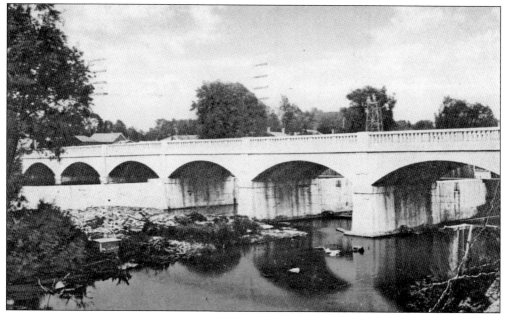

CEMENT BRIDGE. This new six-span concrete bridge across the river at Locust Street was built by Cleveland & Sons Company of Brockport, New York, and opened for traffic in April 1915. The bridge and the dam adjoining it to the west eliminated the need for the old dam in the river.

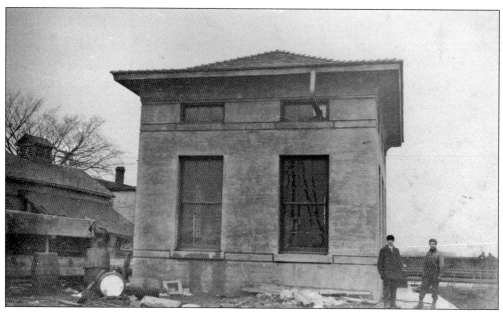

LOCK HOUSE. This image was taken on January 21, 1916, and shows the barge canal lock house No. 4. The lock house was constructed when the canal was rebuilt in 1913–1914.

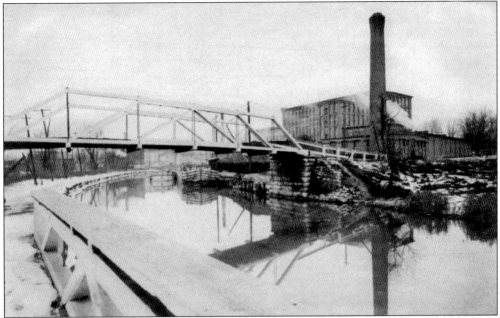

GORHAM STREET. The contract to build this bridge, crossing the barge canal just east of the Waterloo Woolen Mills and Distillery Island, was awarded to the Scott brothers of Rome, New York, in September 1915. This view looking west shows part of the woolen mills on the right.

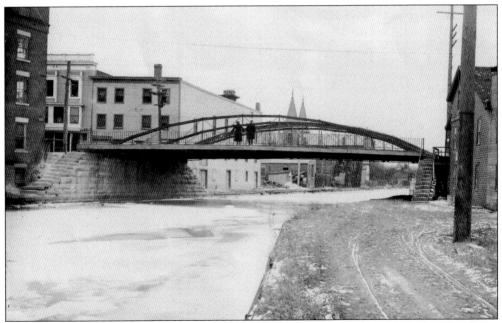

WASHINGTON STREET BRIDGE. This bridge replaced the stone bridge that was in place for almost 100 years. It was built by contractor John Bellardino of Seneca Falls and constructed of steel and concrete with a new type of floor known as an armored floor. The floor was made of concrete, supported by steel grids running lengthwise and crosswise. Made up of two spans of 52 feet each, it opened to the public on May 6, 1936.

Three

INDUSTRY THRIVES

The Seneca River enabled industry to thrive in the village of Waterloo, New York. The years between 1860 and 1900 brought a variety of industries to Waterloo, and many of the products gained widespread reputation for quality. Industry gave way to innovation in Waterloo, as many new ideas were developed here.

The early days saw a number of mills built to mill a variety of different products. There were sawmills, flour and woolen mills, and the Waterloo Organ Company. Both were well represented at the World's Columbian Exposition in Chicago in 1893. The woolen mill sent 50 different pieces of cloth it manufactured and 200 of its famous shawls. The Waterloo Organ Company received a bronze medal and a ribbon for its Malcolm Love Piano.

In addition to the mills, there were a number of other products made here. William B. Clark began manufacturing wheel spokes in 1860. Clark invented another type of wheel in which the hub was made of elm and on each end a heavy iron band one to four inches thick. It was then turned down to the appropriate size. He made wheels of every description from sulky wheels to the ones used on large steam-fired engines. Waterpower and steam ran his factory.

There was the Waterloo Iron Works, makers of heavy machinery, Waterloo Wrought Iron Company and Waterloo Washboard Factory, malt houses, a yeast-manufacturing company, and several distilleries. Then there was the wagon company. They manufactured beautiful parade wagons and simple wagons. As the automotive industry started to take off, they converted the factory to be able to produce station wagons, or "woodies." They went on to make several types of station wagons and buses.

There was a company that produced street railroad cars and train cars. The Pullman car was invented in Waterloo by Frederick H. Furniss in 1858 and called the Furniss Sleeping Couch Car until he sold the patent to George Pullman. His car was on display at the World's Fair in New York City.

Ryan and McDonald of Waterloo built locomotives and a variety of railroad cars. They specialized in heavy machinery. McDonald built the Belt Line Tunnels in Baltimore and then went on to build the subway in New York City.

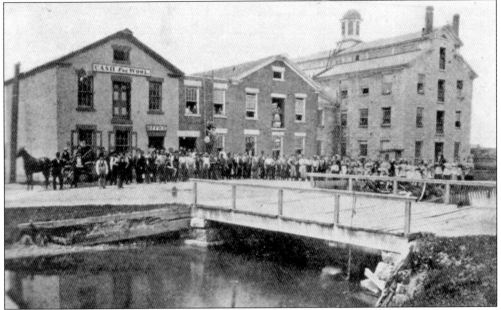

THE ORIGINAL WOOLEN MILL—WEST MILL. Through the efforts of John Sinclair, Jesse Clark, and Richard P. Hunt, the Waterloo Woolen Mills were started. It was incorporated in 1836. At the time, it manufactured broadcloth and cashmeres in the West Mill. The mills were located on East Main Street, between East Main Street and the Seneca River. In 1844, the second stone mill (the East Mill) was built.

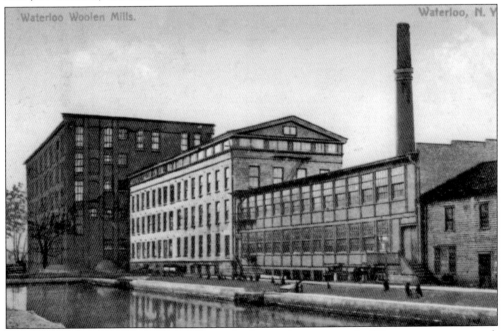

WATERLOO WOOLEN MILLS LOOKING EAST. As the need arose, more buildings were constructed. From 1848 to 1875, they manufactured primarily shawls but also had a wide reputation for their plaid and blanket shawls. By the 1880s, they were manufacturing woolen goods and producing about 800,000 yards per year, in addition to the shawls.

THE OFFICE BUILDING OF THE WATERLOO WOOLEN MILLS. From 1850 until 1875, Thomas Fatzinger was the president of the woolen company. The Waterloo Woolen Mills wired their facility for electricity in 1885 and turned the lights on December 12, 1885. (Author's collection.)

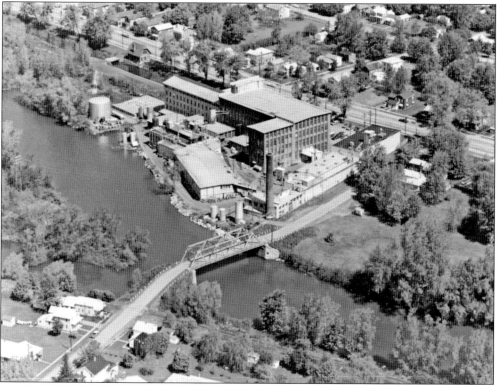

AERIAL VIEW OF THE WATERLOO WOOLEN MILLS. The image above shows the actual buildings that made up the Waterloo Woolen Mills: the former West Mill, then the carpenter and machine shop, the finishing mill, the stone mill, the steaming and carbonizing buildings, the Main Mill, the dye house, the wool scouring and picking building, and the wool storage house. The office building is located at the far west end of the mill plant on East Main Street. In June 1891, a new weave room of the mill was completed.

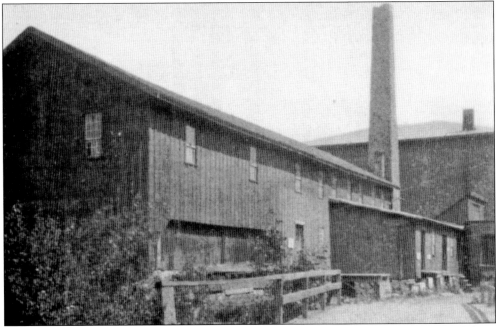

BARBER AND DECKER PLANNING MILL. The Barber and Decker Planning Mill was formed about 1902 on the site of the old Van De Mark sawmill. They installed modern machinery, which allowed them to manufacture sashes and doors. They also did general scroll sawing and wood turning. O.R. Barber was a teacher for a number of years, superintendent of the Clapp Wagon Company in Auburn for about eight years, and foreman in the Waterloo Organ Company factory before starting this business. E.R. Decker worked for the Waterloo Wagon Company and the Waterloo Organ Company before joining Barber in this partnership.

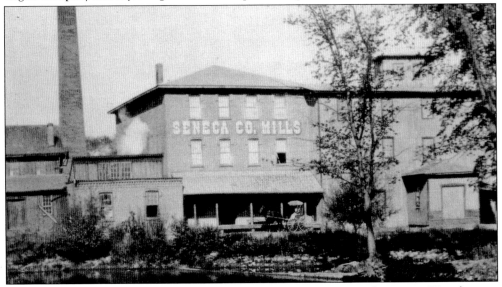

SENECA COUNTY MILL. The largest and one of the most important industries in Waterloo was the manufacturing of flour, meal, and feed. The South Waterloo Mill, owned by L.L. Smith & Company, produced about 100 barrels a day of the over 400 barrels produced by these four flour mills together on a daily basis. Located just south of their flouring mill is their sawmill.

SOUTH WATERLOO MILL. This mill produced about 100 barrels a day. They shipped flour not only to the East and Midwest but also to Newfoundland, Brazil, and the West Indies.

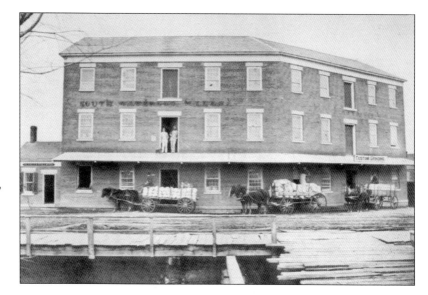

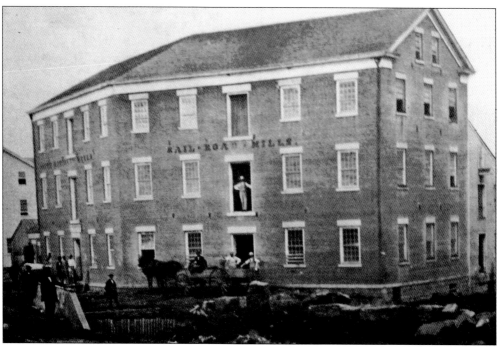

RAILROAD MILL, ALSO KNOWN AS THE BRICK MILL. On December 31, 1891, the large brick mill known as the Railroad Mill, owned by Sweet, Mongin & Cook, located on the east side of Washington Street on the site just north of the barge canal, burned. The mill was a four-story building full of grain. After the fire, the first floor of the building was all that was left. It was used for a number of businesses: an electric light–generating plant, hose house for the Seneca Hose Company No. 4, and a storehouse of Empire Gas & Electric Company; it was finally torn down in the winter of 1943–1944.

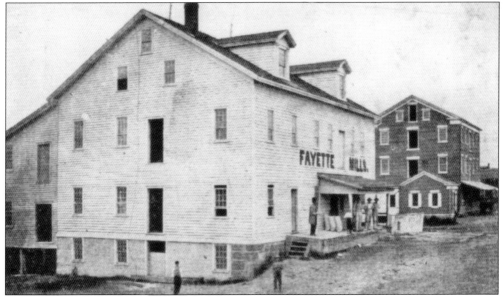

FAYETTE MILLS. The Fayette Mill was located on the east side of Washington Street, adjoining Tracey Development Company race on the north. It was located on nearly the same site as the original Bear Gristmill, the first business venture in the town of Waterloo. The mill was originally built by Lucas & Alleman and run by waterpower. Owned by Pierson & Becker, this mill produced about 110 barrels a day. It ran successfully for about 145 years. The mill was sold a couple times during the 1940s and was the last flour mill operating in the village. It was demolished in late 1948 and early 1949.

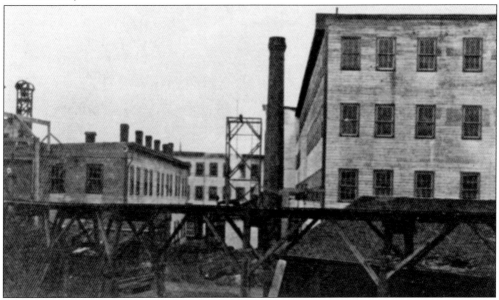

WATERLOO WAGON COMPANY. The original Waterloo Wagon Company was built near the corner of Elizabeth and Church Streets in 1882. They equipped their plant with 150 electric lights in 1885. By 1903, the size of the factory was 126,000 square feet, and they were selling about 5,400 vehicles per year. They manufactured gentlemen's driving wagons, single and double carriages, elegant buckboards, cabriolets, and depot wagons.

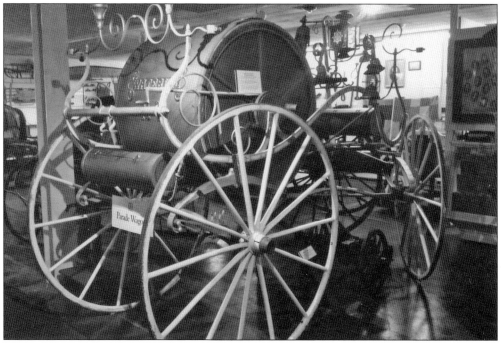

PARADE WAGON MANUFACTURED BY THE WATERLOO WAGON COMPANY. Produced by the Waterloo Wagon Company, the style of wagon shown here was sold as a parade wagon. (Author's collection.)

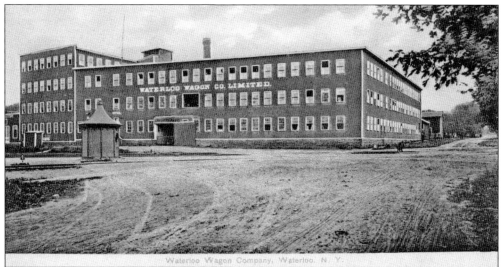

WATERLOO WAGON COMPANY, LTD. TO WATERLOO BODIES, INC. As wagons began to go out of style and automobiles came in, this factory was converted to the Waterloo Body Corporation. Their first wooden body was a suburban for a 1922 Ford Model T. They also made an open-delivery body for a Model T Ford chassis. Most of these wooden body styles are now called woodies. In 1932, the company was sold to Robert Campbell of Tarrytown, New York. It was reorganized into the Mid-State Body Corporation. The facility was greatly enlarged and also known as the Waterloo branch of the Hercules-Campbell Body Company. Mid-State Body Company held the contract for manufacturing all of the 1939 Chevrolet Motor Company's suburban or station wagon bodies.

35

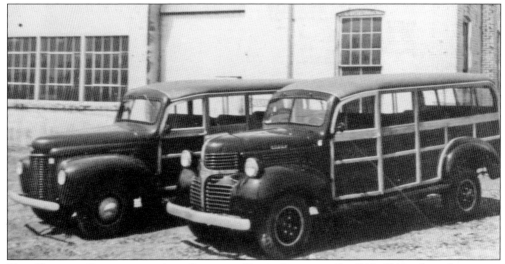

TWO VEHICLES PRODUCED BY THE CAMPBELL BODY COMPANY. In 1918–1919, when the wagon business began to drop off because of changing times, the Waterloo Wagon Company, Ltd. began to manufacture auto bodies, especially for light trucks. It adapted its well known station wagon bodies to automobile chassis and was among the first, if not the first, to manufacture station wagons. In the 1930s and 1940s, under plant manager Karl Bernhardi, workers operated in assembly-line fashion, with different crews responsible for doors, sides, tailgates, and finishing. They made the new Campbell suburban for a Ford chassis and for a Chevrolet chassis similar to the ones shown.

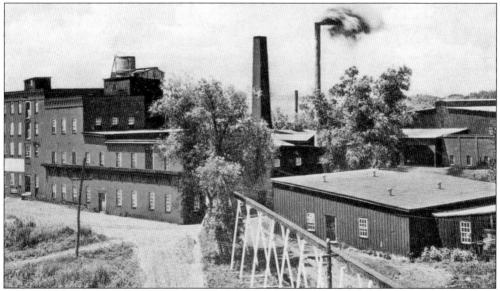

COLUMBIA DISTILLING COMPANY. Walter B. Duffy of Rochester, New York, was a large stockholder in the New York and Kentucky Company, and in the fall of 1900 his son became the manager of the plant. Duffy's malt whiskey was then being produced in Rochester, but within a few years they transferred production to Waterloo, and the Columbia Distillery became the sole manufacturer of this whiskey, which soon became known from coast to coast as one of the finest whiskies made in the United States. In 1906, the Columbia Distilling Company built a seven-story brick warehouse with a capacity of 21,000 barrels. This new building was completed in October 1906.

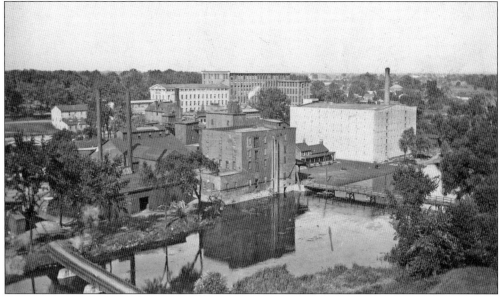

DISTILLERY ISLAND (ABOVE) AND THE ISLAND DISTILLERY (BELOW). This island in the Seneca River was called Distillery Island. The island distillery burned in the summer of 1874. It was the original John Watkins mill, built in 1816. In 1897, Hoffman & Ahlers of Cincinnati, Ohio, contracted to put this structure in running order; this was completed, and the distillery reopened in June 1898. They started using 500 bushels of grain per day, producing five gallons per bushel. They built a new barrel house, and the Lehigh Valley Railroad constructed a wye on the site to bring in coal and grain and take out the final product. In 1899, the New York and Kentucky Company purchased the distillery and continued to make whiskey and high-quality wines.

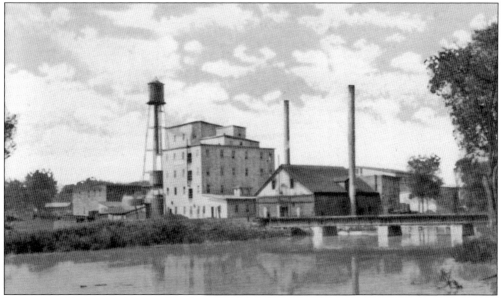

INDUSTRIAL DISTILLING PLANT. The Industrial Distilling Plant built a large frame structure on the south side of the river, east of Race Street, just about opposite the Columbia Distilling Company. They had a larger capacity and ran until the days of Prohibition.

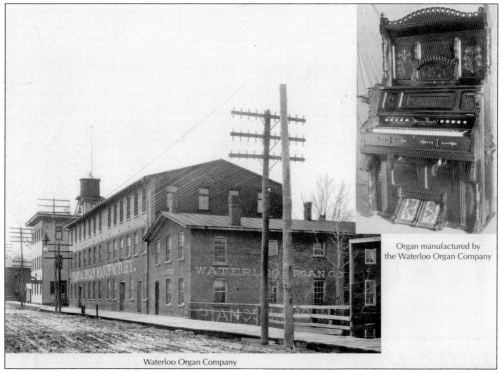

Organ manufactured by the Waterloo Organ Company

Waterloo Organ Company

WATERLOO ORGAN COMPANY. In 1861, the Organ Company began manufacturing the Waterloo Cabinet Organ in a very small factory on Virginia Street. After a fire in 1881 destroyed the entire factory, Malcolm Love and Alexander C. Reed purchased the Waterloo Organ Manufacturing Company. It was incorporated in 1888 as the Waterloo Organ Company.

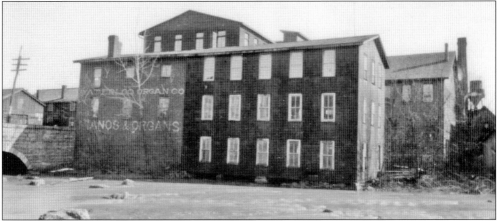

WATERLOO ORGAN COMPANY. In 1889, the Waterloo Organ Company decided to manufacture pianos as well as organs. They hired Seebald Mennig, who drew up the scale (the interior plan, length of strings, method of putting in the sounding board, and so forth) for the Malcolm Love Piano. The old yeast factory on the east side of Church Street just north of Main Street was chosen for the factory site. The woodwork for the pianos would be made at the Waterloo Organ Company on Washington Street. On March 13, 1897, the piano factory (Waterloo Organ Company), in which the Malcolm Love Pianos were manufactured, burned. This was the old Waterloo Yeast Factory. The patterns, tools, machinery, stock, and materials were destroyed. The Waterloo Organ Company purchased the site south of the Organ Company on Washington Street, the William W. Wood mill site, and built a new three-story frame piano factory. They were using the new building in June 1897. This plant would later become the Vough Piano Company.

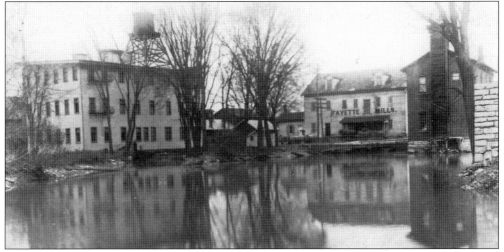

VOUGH PIANO COMPANY. The Vough Piano Company was formed in May 1903. The new company purchased the Waterloo Organ Company and continued the manufacture of Malcolm Love and Alexander Pianos. They soon featured the Vough changeable-pitch piano, an invention of William C. Vough. As many as 700 pianos a year were made and sold through the Eastern United States. The business was sold to Wegman Piano Company in 1913. This facility was modern for its time and especially adapted for the manufacture of high-quality pianos. They purchased the entire plant and property of the Waterloo Organ Company and manufactured Malcolm Love and Alexander pianos along with a new line called the Vough changeable-pitch piano, which was designed and patented by William C. Vough, the president of the company.

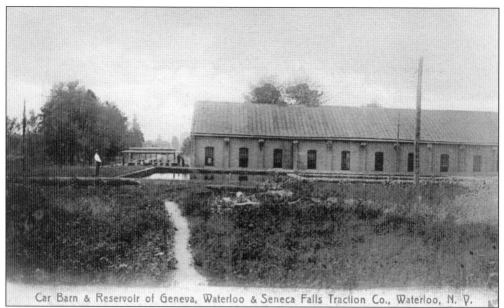

Car Barn & Reservoir of Geneva, Waterloo & Seneca Falls Traction Co., Waterloo, N. Y.

THE TRACTION COMPANY. This facility, located just west of the village, was used as the Car Barn and Reservoir of the Geneva, Waterloo, Seneca Falls and Cayuga Lake Traction Company to house and repair the trolley cars. They provided street surface railway service from Geneva to Waterloo, Seneca Falls and Cayuga Lake, and back.

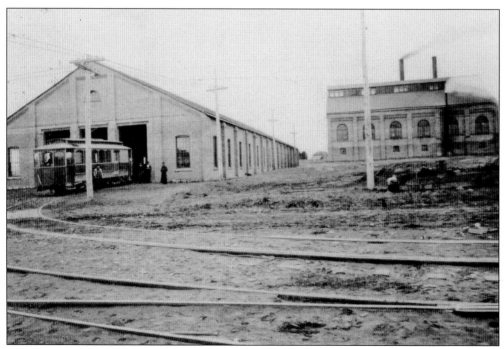

THE CARBARN TO CAMPBELL-VINCENT COMPANY. The carbarns, repair shop, and local office of the trolley line located on West Main Street were purchased in 1939 by the Campbell-Vincent Company and turned into a manufactory. The west building was enlarged and used by the Mid-State Body Company, Inc. to manufacture and assemble school bus bodies until December 1947.

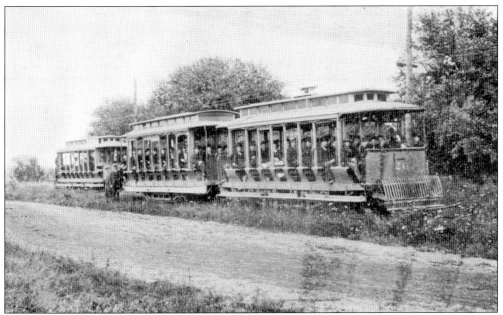

COMMUTER TRAIN. The Geneva and Waterloo Railway Company was granted permission on November 12, 1894, to construct, operate, and maintain a street surface railroad on Main Street as far east as Locust Street. The railway was to be operated by electric power. This is one of the first trolley cars used by the Geneva and Waterloo Railway.

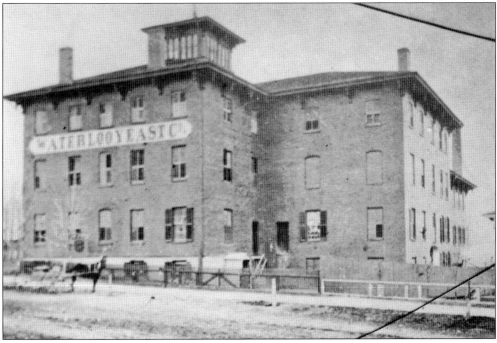

WATERLOO YEAST FACTORY. Twin Brothers Yeast Factory opened in Waterloo in 1817 at 46 West Main Street. They won a prize at the 1876 Centennial Exhibition in Philadelphia, Pennsylvania. Unfortunately, the factory burned down in 1877.

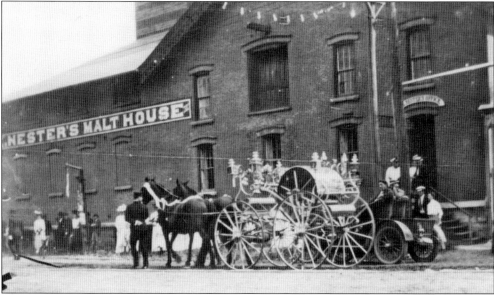

K. Nester's Malt House. During the late 1870s and early 1880s, there were five large malt houses in the village, where thousands of bushels of barley were made into malt annually.

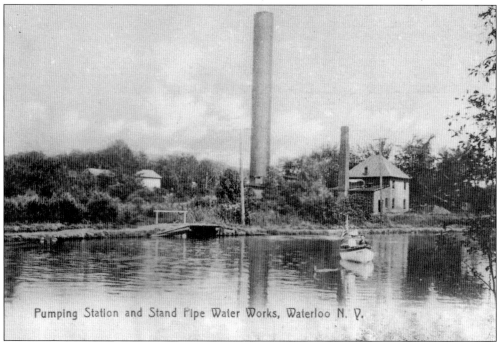

Pumping Station and Stand Pipe Water Works, Waterloo N. Y.

Pumping Station and Stand Pipe of Waterloo Water Company. The Waterloo Water Company was incorporated in May 1886. Work began in June 1886 to build a waterworks plant on Reed Street, with a pumping station run by steam, a large reservoir, and a 135-foot round iron standpipe, 15 feet in diameter. Water was pumped from the river to the reservoir, through filtering material, and then into the standpipe. In August 1887, there were about 203 users of the company's water, and in 1888 it was decided to use hydrants for fire purposes. (Courtesy of Diane Lerch Kurtz.)

CLARK WHEEL WORKS. William B. Clark was 15 when he moved to Waterloo in 1850. He began manufacturing wheels in 1860. By the 1900s, his line of wheels was known throughout the United States. He invented and patented the Clark Patent Wheel. Numerous types of wheels were made at his plant located on East Water Street and Distillery Streets—everything from a sulky wheel to a wheel for a large steam-fired engine. The plant, consisting of four buildings, was run with both waterpower and steam.

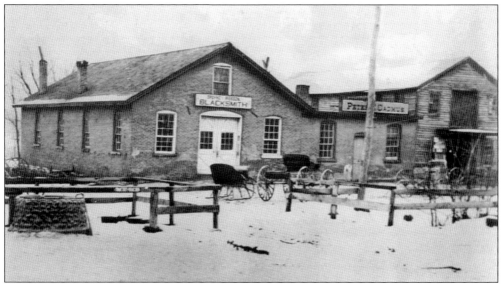

IRON WORKS. Pictured here are the shop of Opdyke & Pierson Blacksmith and Cadmus Wheelwright Shop about 1910. There were also at least two other iron shops, J.O. Spencer Works and Waterloo Iron Works, or Waterloo Wrought Iron Fence Company. J.O. Spencer moved his business from Union Springs to Waterloo in 1883. He purchased land on the north side of the New York Central tracks between Church and Swift Streets. The shops were completed and lighted by electricity in early 1883, the first electric lights in Waterloo. The building was heated with steam, which led to a greater use of steam for heating in Waterloo. He called the business Spencer Wide Awake Works. By 1884, they had turned out 65 engines and 100 threshing machine separators.

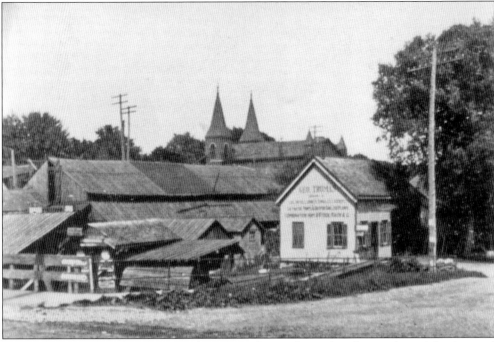

GEORGE THOMAS COAL YARD. Located on Water Street, the coal yard carried wood, lumber, and a line of farming equipment, in addition to coal.

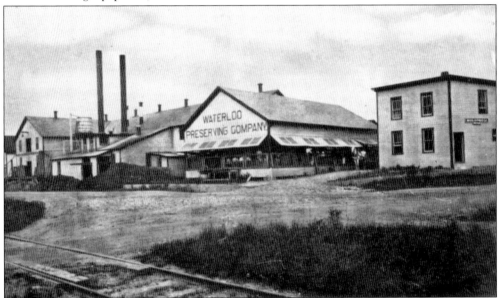

WATERLOO PRESERVING COMPANY. In November 1905, it was proposed to the Waterloo village trustees that a canning factory be built in Waterloo. By May 1906, they had purchased the former Townley & Holden cold-storage plant on Railroad Street, adjoining the New York Central tracks, chose the name Waterloo Preserving Company, and opened for inspection. There were two other canning companies, the Seneca Kraut and Pickling Company and Home Style Food Products Company, Inc. Seneca Kraut was the first sauerkraut factory in western New York. By the mid 1940s, they were using 20,000 to 25,000 tons of cabbage a year and became one of Waterloo's largest industries.

THE FURNISS SLEEPING COUCH CAR. In 1858, Frederick H. Furniss of Waterloo invented the Furniss Couch Car. It was exhibited at the World's Fair in New York City. He sold the patent to George Pullman, who organized the Pullman Company and renamed it the Pullman car. The original model is owned by the Waterloo Library and Historical Society.

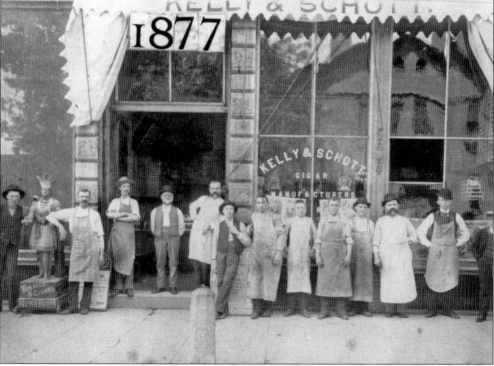

CIGAR INDUSTRY. This image shows Schott's cigar-manufacturing shop and his crew. He and J.J. Carroll manufactured cigars and shipped all across the country. The year 1947 marked the end of the era of cigar manufacturing in Waterloo. For years, Robert Beebe manufactured the Croquet and 962 cigars. The Croquet was originally manufactured by Kelly and Schott and was the leading 5¢ cigar in Seneca County. The 962 was manufactured by Leroy A. McDuffie. Handmade cigars were one of the larger industries in the village until machine-made cigars finally took over. Many cigars were made in Waterloo, including J.K. and El Carol, both 10¢ cigars, and Croquet, 962, Bloomer, and Chief Logan, all 5¢ cigars.

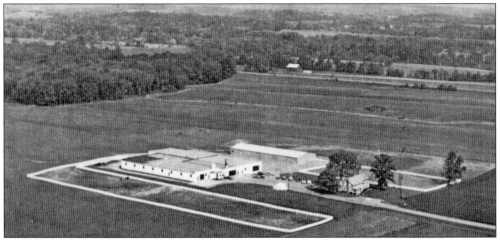

PORTER-WAY HARVESTER MANUFACTURING COMPANY. Porter-Way Harvester Manufacturing was organized in 1945 when inventor, designer, and manufacturer Wellington W. (Jock) Porter came up with an efficient economical pea-harvesting machine. By developing and improving his ideas, his company has received more than 80 patents. Porter started out in a small barn on his farm north of the village of Waterloo. With his ingenuity and work ethic of "always take care of our customers," he was able to grow his business into this large manufacturing facility. (Courtesy of Linda Porter DiPronio.)

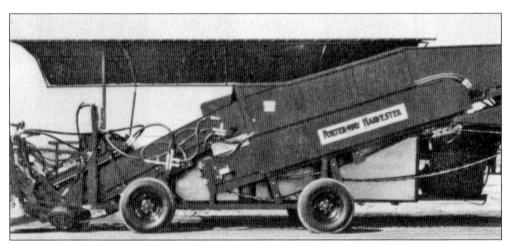

PORTER-WAY PEA-HARVESTING MACHINE. Today, Porter-Way harvester machines of many types are sold and used around the world, from the United States to Africa, Europe, Australia, and Asia. This is a new model of the pea harvester. They are bright red with American flag decals. They have machines to harvest peas, spinach, asparagus, cucumbers, pumpkins, Brussels sprouts, tomatoes, and many other vegetables. (Courtesy of Linda Porter DiPronio.)

Four

SMALL-TOWN BUSINESSES

The industrial growth in Waterloo brought an increase in population, which led to the development of small businesses. Many of these small businesses provided services like hotels, restaurants, food, clothing, and many other types of supplies needed for everyday life in Waterloo.

In 1862, there were eight hotels in Waterloo: the American Hotel at 98 Main Street; Cottage Home at 100 and 102 Elisha Street at the corner of Virginia Street; the Eagle Hotel at 190 and 192 West Main Street; the Farmers' Exchange at 22 Fayette Street; the Fayette House at 14 Fayette Street; the Franklin House at 36 and 38 Washington Street; the Grove Hotel at 46 Williams Street and the Madison House at 258 Main Street. In later years, there were more. The prestigious Towsley House was one of the best hotels in all of western New York.

Many other businesses developed in Waterloo during the late 1800s and the early 1900s. As more homes were built, the need for additional stores grew. There were far too many to try to include all of them in this writing, but one will see that every need and want was satisfied with a shop of some sort. There was everything from candy and confectionery stores to grocery stores, many small neighborhood types, clothing stores, shoe and boot stores, restaurants, variety stores, photographers, drugstores, movie theaters, tailors, and barbershops—and the list goes on.

The village grew so rapidly that for a time there were few equal to it in western New York.

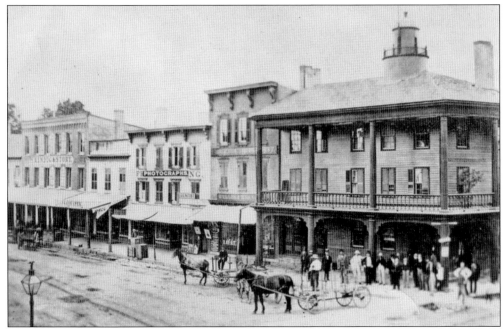

EAGLE TAVERN. Pictured here in 1866, this tavern was located on the northwest corner of Main and Virginia Streets. It was originally built and operated by Quartus Knight as the Waterloo Coffee House. It was opened in 1819 as the Eagle Hotel then the Eagle Tavern. The building was sold to Alonzo Towsley in 1863. It was destroyed by fire in 1869. (Courtesy of the Terwilliger Museum.)

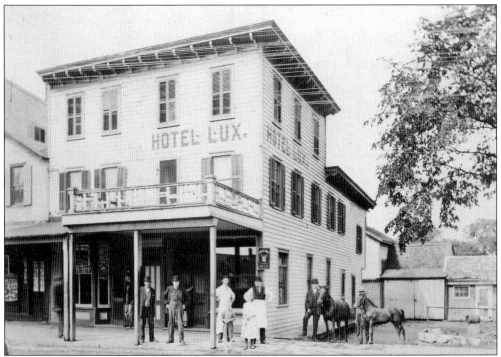

HOTEL LUX. This hotel was located on Washington Street; pictured here from left to right are Joseph Whartenby, Edward Lux, Billy Beck, and Barney Marshall.

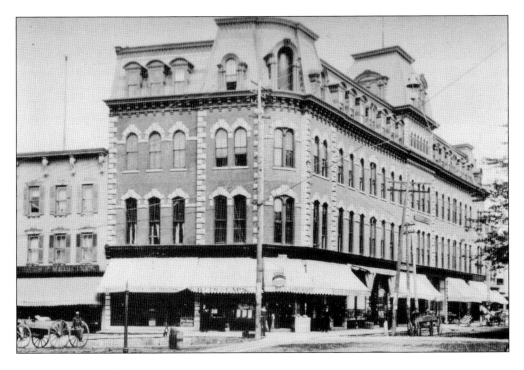

TOWSLEY HOUSE. Located on the corner of Main and Virginia Streets and adjoining the Welles and Branch Block on the west side, this hotel was built by Alonzo Towsley at an initial cost of approximately $100,000. The architect was J.R. Thomas. The hotel was the finest and most well constructed hotel in western New York. The building was four stories tall and 40 feet wide on Main Street, 150 feet long on Virginia Street, and 75 feet wide on the north end. The mansard roof contained a niche for a statue of Alonzo Towsley, but none was ever erected. The back portion of the hotel and the whole top floor burned in 1900. The renovated building is pictured here; it is only half as long and one story less.

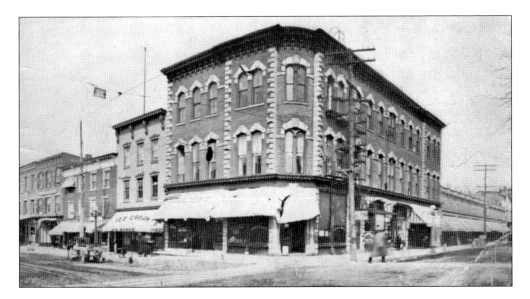

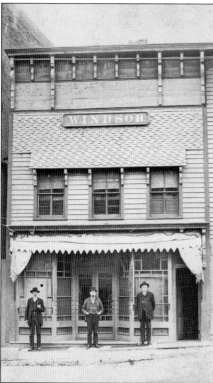

HOTEL FLORENTINE. This hotel was located on Virginia Street at Elisha Street with the hotel in back facing the railroad. In April 1902, George M. Pay leased the property, then known as the DeWitt House, located on Virginia Street and gave it the name the Florentine. In addition to the main building with the office, bar room, parlors, dining room, and guest chambers, there was a large two-story house with a large hall, sitting rooms, and suites.

DINING PARLORS. The Windsor Hotel and Dining Parlors were located on the east side of Washington Street, south of the Academy of Music Block. They were owned and operated by Schott & Strayer.

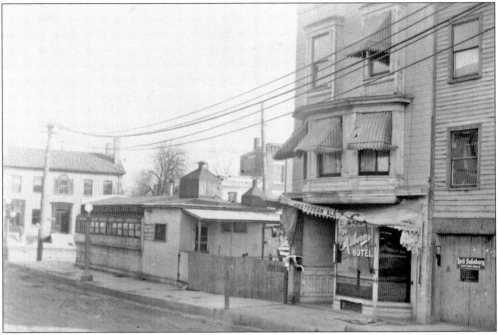

THE AUBURN. This hotel was located on the east side of Washington Street just south of Emmett's Diner. Emmett's Diner was on the corner where the post office stands today. It was a three-story wood-frame building with a bar on the first floor and rooms to rent on the second and third floors.

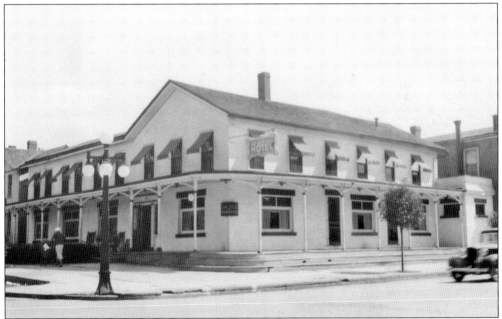

BRUNSWICK HOTEL. Located on the southeast corner of Virginia and Williams Street at 42 Virginia Street, the Brunswick Hotel was originally the Ashmore House, which was first listed for business in 1869. C.E. Wooden renamed the Ashmore Hotel in 1873 as the Commercial Hotel. J.R. McWilliams was listed as the proprietor for the Brunswick Hotel. The New Brunswick burned in 1960, when Andrew Osborne was proprietor.

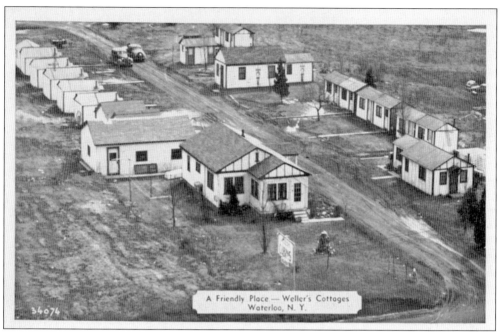

A Friendly Place — Weller's Cottages
Waterloo, N. Y.

WELLER COTTAGES. Another type of overnight accommodations that were built in the late 1940s and 1950s to accommodate travelers were small cottages. The Weller Cottages were located on Routes 5 and 20 just west of the village.

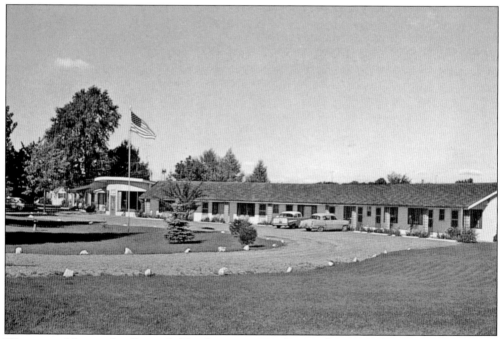

WATERLOO MOTEL. Small motels like this one popped up as the automobile became more and more popular. This one was located on the Waterloo-Geneva Road just west of the village.

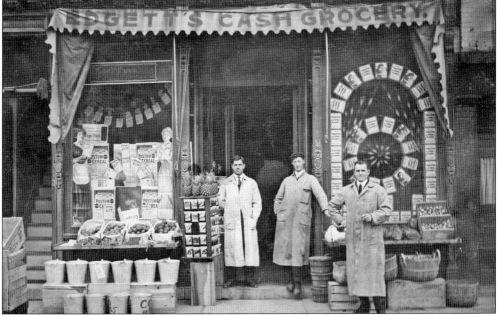

EDGETT'S GROCERY. Pictured here in 1911 are, from left to right, Bert Edgett, Floyd Holben, and William Edgett. The store, originally Henry Wells' Drug Store, was located on West Main Street.

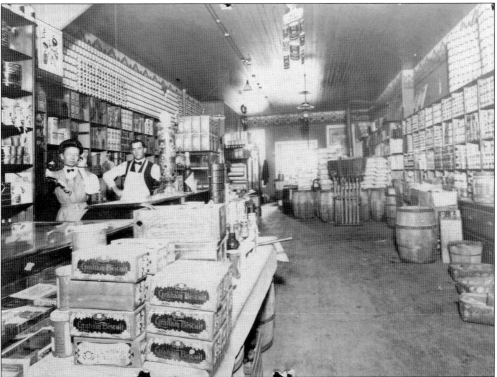

INSIDE EDGETT'S. This image shows the interior of Edgett's Store in 1910. Pictured are Jennie and William Edgett, owners.

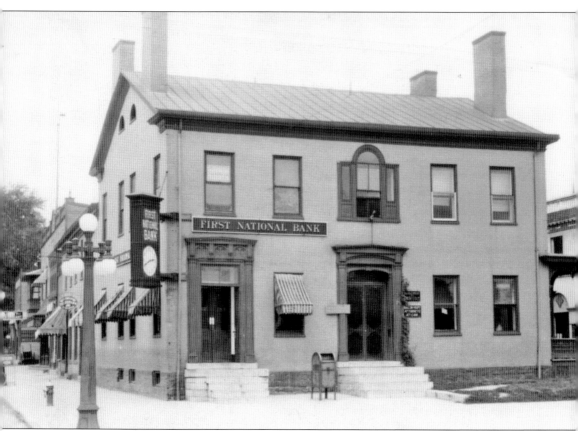

FIRST NATIONAL BANK. The First National Bank of Waterloo is one of the oldest banks organized under the National Banking Act of 1863. It was originally the Seneca County Bank, which was organized on March 10, 1864. Originally located on the northeast corner of Main and Virginia Streets, it moved to the northwest corner of Main and Virginia Streets after the Towsley House fire.

SMITH'S DRUG STORE. This business was owned by R.G. Smith and his son Fred G. Smith since 1870. In 1895, Fred G. retired and his son Fred F. Smith carried on the business. He was active in the village and served as county treasurer from 1902 to 1905 and police justice for the town of Waterloo. Smith's Drug Store was located on the north side of Main Street.

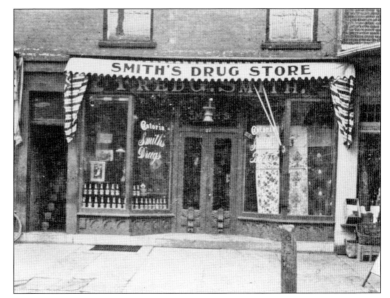

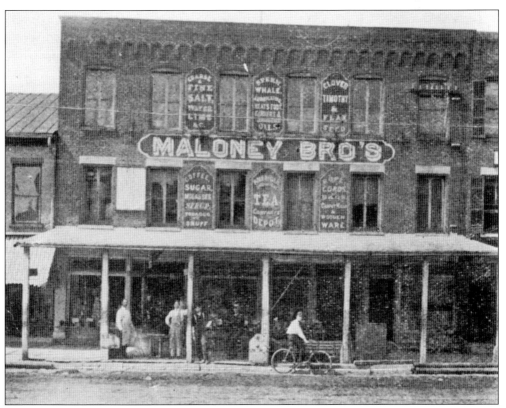

MALONEY BROTHERS. This grocery store, located on the north side of West Main Street, was one of the largest of 18 or more grocers in Waterloo at the time. It is shown on the list of businesses in 1885 through 1930. In December 1885, Maloney Brothers shipped out 12 tons of poultry for Christmas. Kendig and Story shipped 20 tons, and A.C. Reed shipped five tons.

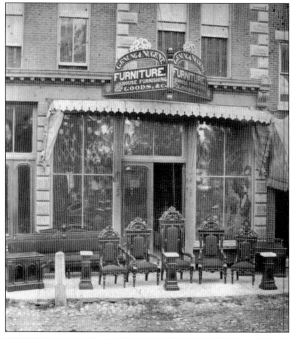

GENUNG & NUGENT. Pictured here in 1870, this furniture store was located on the south side of West Main Street. It later became Nugent's Hardware Store.

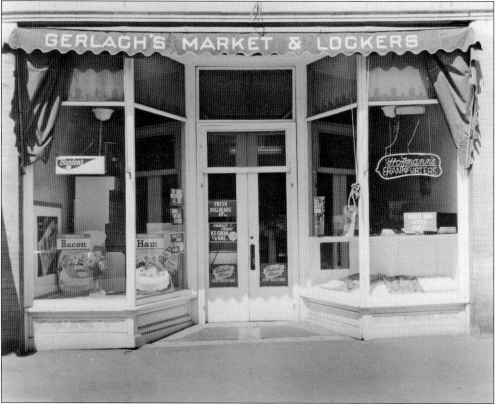

GERLACH'S MARKET. This market was purchased by George Gerlach in 1951 and located at 23 Virginia Street. He ran the business for about 10 years, and it later became Bill's Market.

FAIRLAWN STORES. This neighborhood grocery store is located at 14 Swift Street, the only grocer to be in continuous operation since it opened in the 1920s. It was Coggins Grocery in the 1930s through the 1950s and was owned by Raymond and Alice Coggins. It later became Bushes and then D&M Grocery, owned by Don and Marie Strader. It is currently owned by Steve and Shelly Mueller and is still called D&M Grocery.

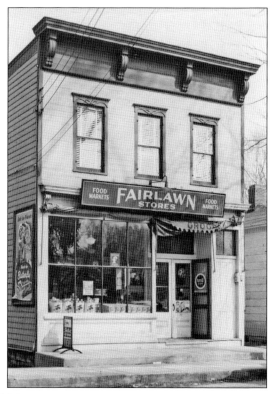

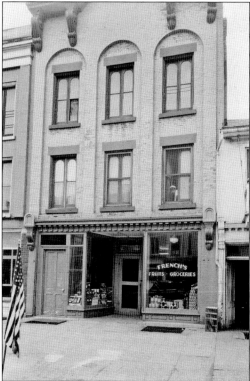

FRENCH'S MARKET. At 15 West Main Street was one of the most popular small grocery stores in the 1950s. This store was owned and operated by Samuel and Rose French.

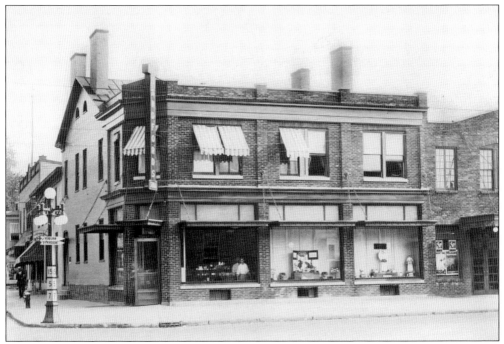

SANDFORD'S DRUG STORE. Pictured here in 1934, this corner store was a liquor store, then a drugstore owned by Milton P. Sandford. The drugstore had a soda fountain counter. It was also Siegrist's Drug Store.

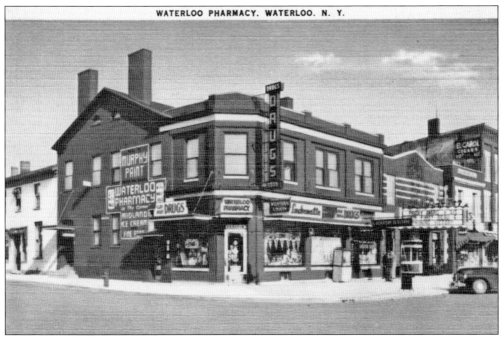

DRUGSTORE AND THEATER. In this image from 1938, Sanford Drugs is on the left and the State Theater is to the right.

GRANITE WORKS. The Waterloo Granite Works was owned and operated by Bert A. Cromie and his wife, Grace. They made granite cemetery markers in the early 1900s. At that time, a marker set in the cemetery would cost about $50.

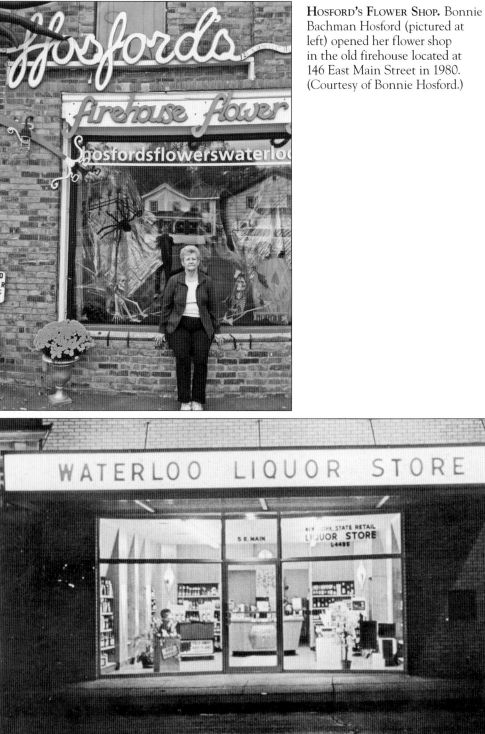

HOSFORD'S FLOWER SHOP. Bonnie Bachman Hosford (pictured at left) opened her flower shop in the old firehouse located at 146 East Main Street in 1980. (Courtesy of Bonnie Hosford.)

WATERLOO LIQUOR. New York State's smallest package store is located at 3 East Main Street in Waterloo. Mildred and Jerry Freeman opened for business on October 1, 1963.

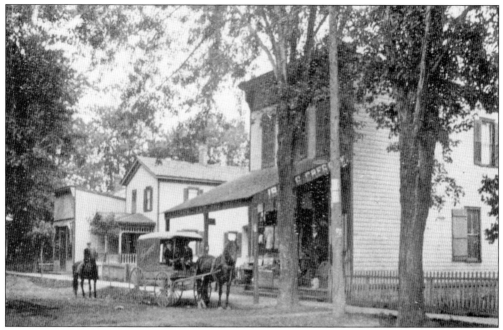

ISAAC G. GREGORY'S STORE. The property is located at 35 Swift Street. Born in Somersetshire, England, in July 1850, Isaac was the youngest son of Henry and Jane Laney Gregory. He was less than three years old when his father died, leaving a wife, four sons, and two daughters. In the winter of 1854, his mother came to this country with her family and settled in Waterloo.

COGGINS. This small neighborhood grocer was located at 14 Swift Street. It was owned and operated by Raymond and Alice Coggins and later became D&M Grocery.

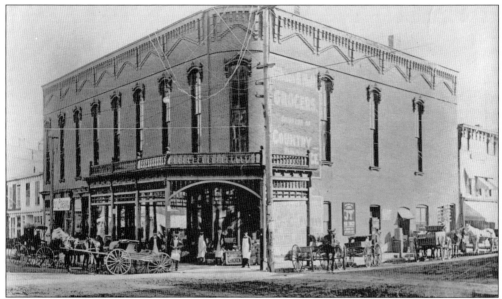

ACADEMY OF MUSIC. Pictured here in the 1890s with the village bandstand on the canopy, the Academy of Music had the largest hall space in the town. The hall was on the second floor. In February 1890, the Burchim Brothers of South Waterloo gave an exhibition of their horizontal bar work in the Academy of Music. These brothers became famous with Siegfried Sautelle's circus and originated numerous acts on the horizontal bars. Many shows were performed at the academy until it was destroyed by fire in 1904.

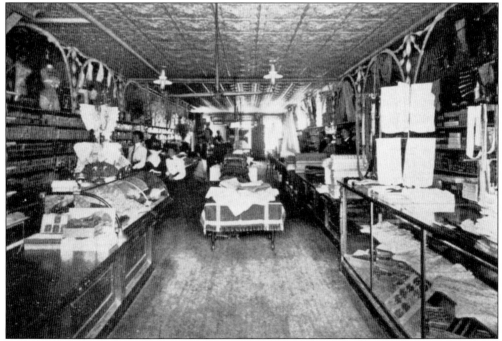

J.M. GARRISON'S. This image shows the interior of the J. M. Garrison Dry Goods Store in Waterloo, on or near Main Street, in the early 1900s. Wages at that time for unskilled labor in a shop like this would be from $7 to $9 a week.

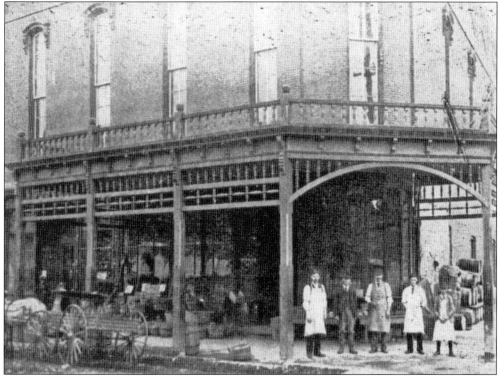

GIBSON GROCERY AND MEAT MARKET. This market was located in the same building as the Academy of Music. James W. Gibson was born in Glasgow, Scotland, in 1861 and came to this country when he was six years old. He traveled and worked at numerous trades until he came to Waterloo around 1893, where he worked for the Waterloo Wagon Company. In 1898, he purchased the business of McCarthy & Graham, a grocery located on the southeast corner of Main and Virginia Streets. With his careful management, he was able to grow the business until patrons not only from Waterloo but also from all of the area villages came to shop. He was known for his fair dealings and honest methods. He also established a meat market connected to the grocery store; it, too, was a big success.

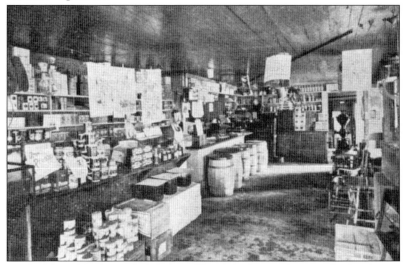

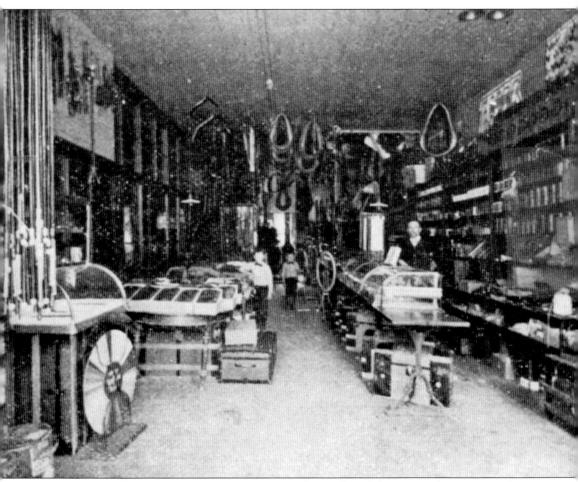

R.J. Brophy's Harness Shop. In 1903, R.J. Brophy purchased the L.R. Jenkins Harness Store at 46 West Main Street after having worked in the store for eight years. He made both single and double high-grade harnesses, using the best oak-tanned leather. He also carried a less expensive line of harnesses, dress-suit cases, trunks, bags, blankets, robes, and whips. He also carried a line of bicycles, sun-proof paints, flexible cement roofing, and the magnesia paint applied after the roofing is put down.

BARBERSHOP. In the early 1900s, there were at least three large barbershops like this in Waterloo. This one was owned by P.H. Duffy, the barber pictured on the left. Barbers typically wore a white shirt, a bow tie, and a white jacket while they worked.

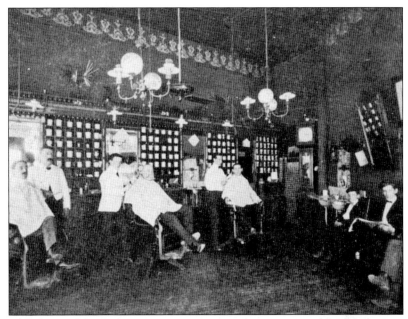

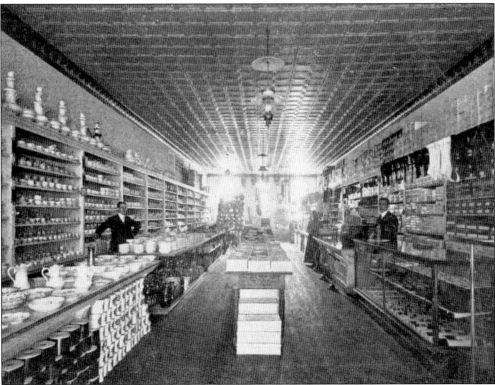

KROHNGOLD'S. Located at 88 Virginia Street, the Krohngold brothers, Maurice and Jacob, purchased this store in 1898. It was very small at the time, but they were able to grow the business to include customers from all surrounding towns and villages. Their stock consisted of a general line of underwear, hosiery, enamel and tinware, and notions. In the basement they carried such things as trunks, valises, glassware, and crockery.

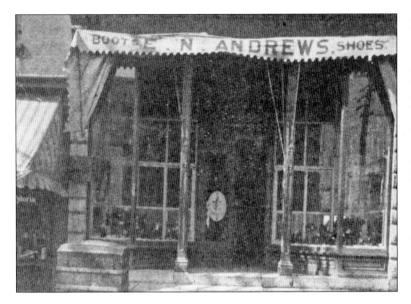

E.N. Andrews Shoe Store. In 1898, Andrews came to Waterloo from Chenango County, New York, after suffering extensive losses to his general store due to a fire. In Waterloo, he built the largest and best-kept shoe store in western New York.

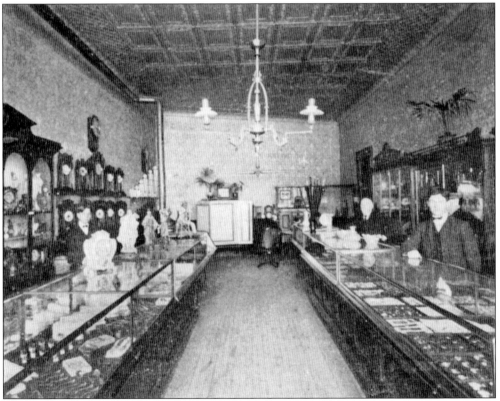

George E. Sherwood's Jewelry Store. Sherwood apprenticed with a firm in Auburn, New York, served during the Civil War, and in 1866 purchased the stock of Milton Knight, in Waterloo. For a number of years, he was the leading jeweler in Waterloo.

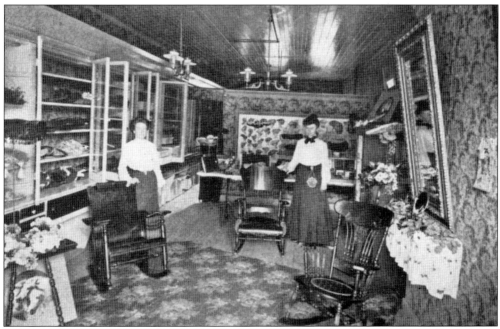

AGNES DARBY'S. Agnes Darby came to Waterloo in 1895 and leased the store located at 29 Main Street for millinery parlors. Her trimmer spent much time in the New York millinery houses, where hats were copied from the Paris pattern hats, making as good a style hat available in Waterloo as was in New York City.

JOHN V. SIMPSON'S. John V. Simpson's Tailor Shop was located at 10 Clark Street. He was a native of England and served as an apprentice for six years and spent one year learning the cutting trade in London. Simpson operated his own shop for a number of years in Bradford, Yorkshire, and moved to Waterloo in 1890. He worked for five years before opening his own shop.

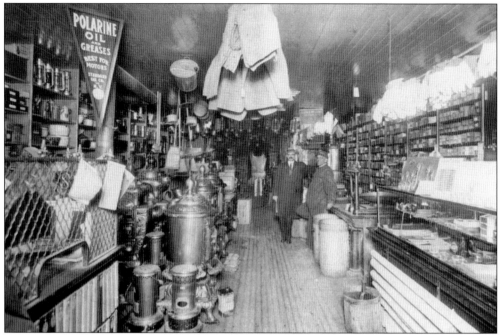

WEBSTER'S HARDWARE. This hardware store was located on West Main Street. (Courtesy of Terwilliger Museum.)

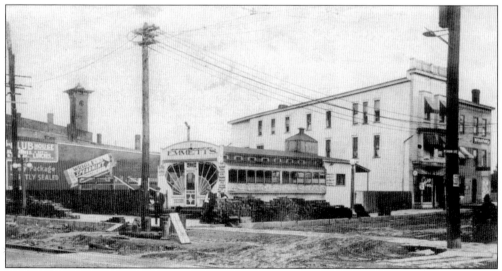

EMMETT KUHN'S. Located on the southeast corner of Main and Virginia-Washington Streets, Emmett Kuhn's Lunch Car was a popular spot. It was established in 1907.

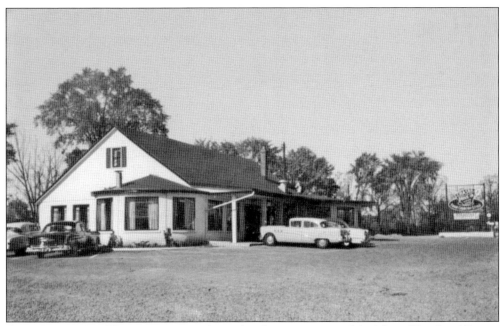

CHASE'S DRIVE-IN. This restaurant was located at the intersection of the Mound Road and Routes 5 and 20. It was Brainerd's Restaurant before it became Chase's Drive-In.

MAC'S DRIVE-IN. Located just west of the village on Routes 5 and 20 is a little slice of Americana. In June 1981, Raymond and Vera MacDougal and Gerald and Cathy MacDougal (pictured from left to right) opened a drive-in restaurant on the north side of the Waterloo-Geneva Road. They offered the first curb service in the area, with carhops Bonnie Birosh and Juanita Rizzieri (pictured with Raymond) in Scottish kilts. It was such a success that they moved the entire front of the building across the road and slightly west, where they still operate today. (Courtesy of Cathy MacDougal.)

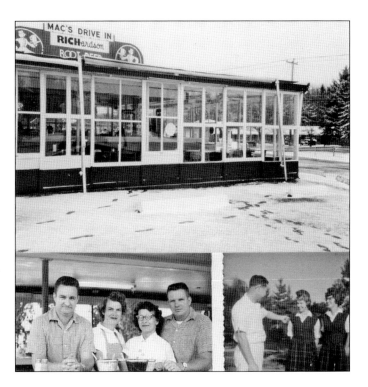

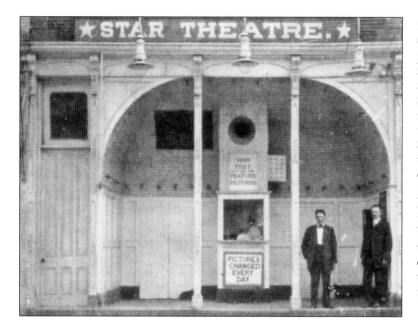

STAR THEATRE. On the lot just east of the Sandford Drug Store on Main Street, a new motion-picture venue called the Star Theatre was built and opened on March 17, 1924, with Marion Davies in *Little Old New York* complete with a five-piece orchestra. It was the first theater in Waterloo.

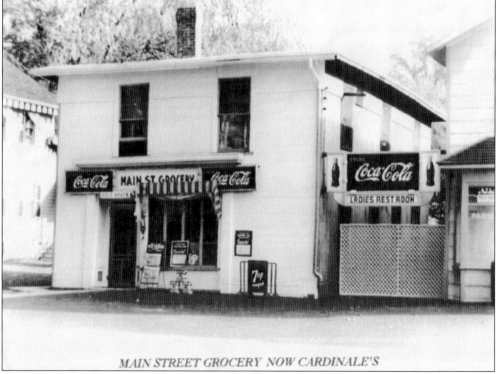

MAIN STREET GROCERY NOW CARDINALE'S

CARDINALE'S. This small neighborhood grocer was located on West Main Street directly across the street from the high school. Students often ate lunch at Cardinale's instead of eating in the cafeteria.

Five

SCHOOLS, CHURCHES, HOSPITALS, AND PARKS

The years from 1860 to 1900 proved to be years of development and growth for Waterloo. Many large public buildings were built during this time frame, including the Waterloo Library and Historical Society and St. Paul's Episcopal Church. Thomas and Levi Fatzinger were the two largest contributors to the building of the church. The brothers were both officers at the Waterloo Woolen Mills. Waterloo's three other large churches were built between 1870 and 1900. St. Mary's Catholic Church was built in 1873; like St. Paul's, it is a limestone building. The United Methodist Church and the Baptist church are brick churches designed by local architect Martin Van Kirk in 1895 and 1897.

Education was an important factor in the development of the village of Waterloo. In the early 1800s, they had private schools and a few state-provided schools under the state legislation. By the mid-1800s the village decided that the school system was not good enough to meet the public's needs. A group of citizens felt that the growing village needed to look at alternatives. They decided to build an academy to provide better education to the next generation. They sold shares of stock for $10 each and hired architects Olmstead & Vreeland to design the school. It became the Waterloo Union Free School in 1847. In 1871, it was enlarged, and in 1882 a more modern building was erected on the property. There were other public schools in the village.

The idea arose in 1918 to develop the Waterloo Memorial Hospital as a memorial for the boys of Waterloo who had participated in World War I. In 1919, they were looking at a community house as the memorial. By the fall of 1919, the committee was still undecided: should it be a community building or hospital? On October 25, 1919, they called a vote. The vote was clear. It was to be a memorial hospital. They soon decided on the Mansion House of Elisha Williams on West Main Street.

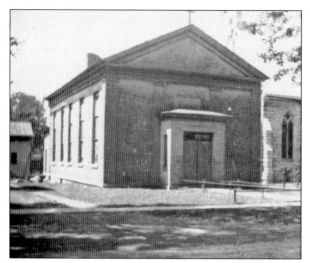

THE ORIGINAL ST. MARY'S CATHOLIC CHURCH. St. Mary's Catholic Church was organized in Waterloo in 1846 when two lots on the west side of Center Street were purchased. The foundation was laid on these lots, and the original building was 30 feet by 40 feet. It was finished in October 1846 and the first mass held on November 3, 1846. This original structure was made into St. Mary's Hall once the new church was completed in 1889. The hall opened in October 1897.

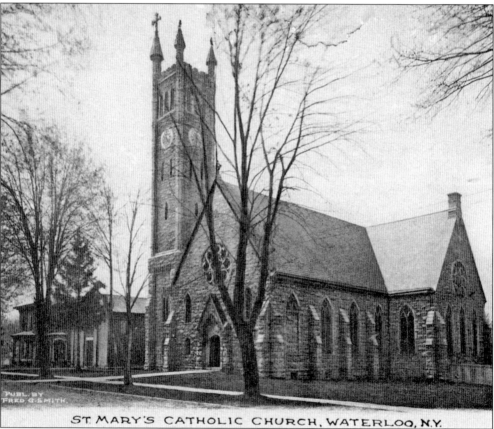

ST. MARY'S CATHOLIC CHURCH, WATERLOO, N.Y.

NEW ST. MARY'S CATHOLIC CHURCH. The laying of the cornerstone for this church, under Rev. Father Lambert, took place in 1873. This beautiful stone church is Gothic in design and known to be one of the architectural gems of the Rochester Diocese. The structure is a cross formation with a chapel attached. The architect was M.L. VanKirk of Waterloo, and the stonework was done by Edson Brothers of Phelps, New York. The interior of the church was finished and dedicated on December 22, 1889, by Bishop McQuaid of Rochester, New York.

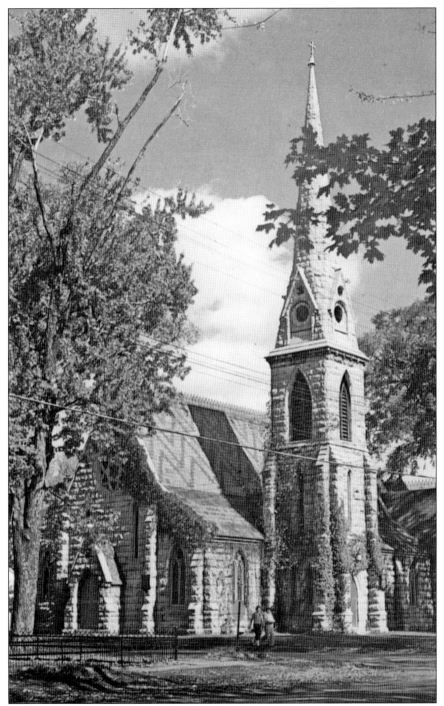

ST. PAUL'S EPISCOPAL CHURCH. St. Paul's Episcopal Church, located on the northeast corner of Williams Street and Church Street, was first built in 1826 as a wooden structure. Pictured here, the church was designed by Henry Dudley of Draper & Dudley, Architects, in 1860. The cornerstone was laid on June 9, 1863. The church was consecrated on May 4, 1865, and is listed in the National Register of Historic Places.

St. Paul's Parish House. St. Paul's Parish House (School) was established in January 1852 with 30 students. In the fall, an addition was built, and by the second year attendance rose to 80. Another addition was made to the building in 1873, and a kitchen was added in 1896. The building was demolished in 1916 in favor of a new parish house. The new parish house was designed by I. Edgar Hill, an architect from Geneva, New York, in 1916. The cornerstone was laid in May 1916.

THE FIRST PRESBYTERIAN CHURCH. Services were held in the courthouse and the central schoolhouse for a number of years. In June 1823, Ruben Swift was chosen to lay the cornerstone of this—the first edifice built for Christian worship in Waterloo. It was dedicated in September 1824 and was owned afterward by the Methodist Protestant Society and used as a church. Also known as the Old White Church, it was used by missionaries of the Mormon Church and later became part of the high school property.

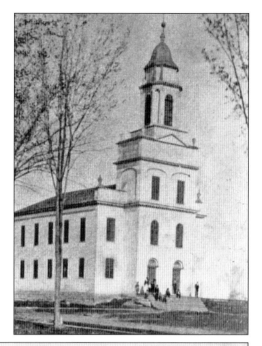

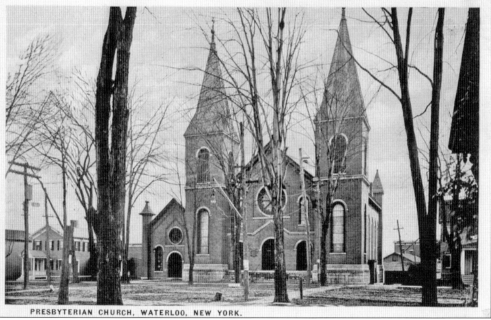

PRESBYTERIAN CHURCH, WATERLOO, NEW YORK.

THE PRESBYTERIAN CHURCH. In 1850, the Presbyterian Church was, in the words of the Rev. Samuel H. Gridley, full, and there was no room for more; he had completed his work in Waterloo and wished to be relieved. This led to the appointment of a new church building committee. The cornerstone was laid August 21, 1850, and the structure dedicated on November 12, 1851. This new church is located on East Main Street, just east of the village. In 1880, it was decided to construct a new chapel east of the church and adjoining. It was dedicated on September 29, 1881. They celebrated the church's centennial on November 10–12, 1917. This church is listed in the National Register of Historic Places.

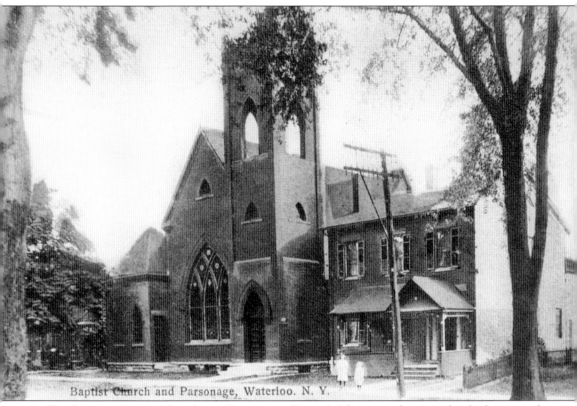

Baptist Church and Parsonage, Waterloo. N. Y.

THE BAPTIST CHURCH (LEFT) AND PARSONAGE (RIGHT). The original society that had organized the first Baptist Church had disbanded in 1853, but a new group organized the Baptist Church in 1863. In 1865, they purchased the Lutheran church in South Waterloo. They used it until 1875, when during a revival, it burned. They met for some time in Towsley Hall (the Grange hall on Virginia Street), until they decided to purchase the property on the south side of Williams Street and build a church. The cornerstone of the new Baptist church was laid on October 9, 1897. The architect was Martin L. Van Kirk. The church was dedicated on February 14, 1899. The Baptist parsonage was the former home of Thomas M'Clintock and Mary Ann M'Clintock.

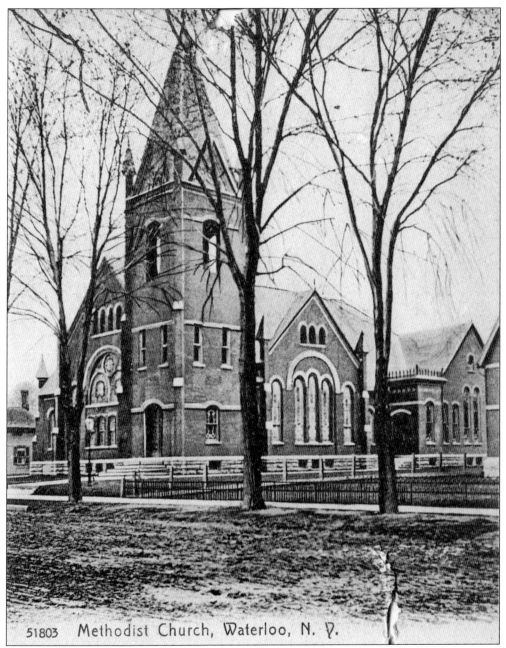

51803 Methodist Church, Waterloo, N. Y.

THE METHODIST CHURCH. The church was formed in Waterloo as the Fletcher Society of the Methodist Church of Waterloo. They built their first church on a site located at Virginia Street and Elisha Street. After a fire, rebuilding, building an addition, and losing more property to the railroad, in 1879 they decided to purchase property away from the railroad. The church finally purchased the lot on East Williams Street known as the M'Clintock lot in 1875; by 1895, they were ready to build a new church. Martin L. VanKirk, architect and member, designed the structure, and Edson Brothers laid the cornerstone on August 17, 1895. The entire cost of this structure was $25,000. The Methodist Church is listed in the National Register of Historic Places.

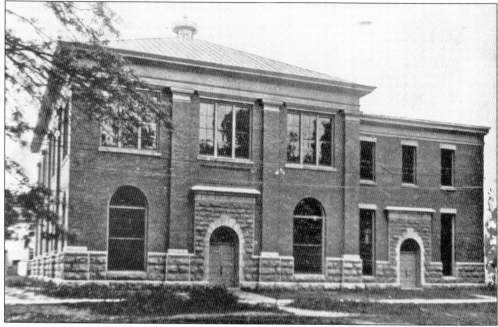

WATERLOO UNION SCHOOL. From its incorporation in 1824, the village of Waterloo had developed private schools and schools furnished under the state school legislation. However, the institution pictured here was not a public school; it was private and one of the first schools built in Waterloo. It was soon changed to the Waterloo Union Free School and located on the site where the Waterloo Academy was to be built.

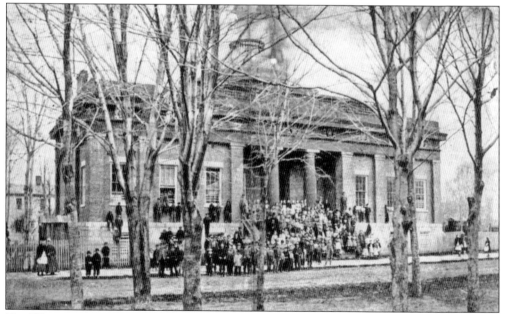

THE WATERLOO ACADEMY—THE ROTUNDA BUILDING. This school was built in the Tuscan style in the early 1840s and called the Rotunda Building because of the rotunda, which rose 15 feet above the roof. It was incorporated by New York State in April 1842 and by the board of regents in August 1842.

WATERLOO UNION SCHOOL. The school had a number of additions to it over the years, but this image represents the school from 1870 to 1901. It was not until 1870 that money was made available to enlarge the school. (Courtesy of Diane Lerch Kurtz.)

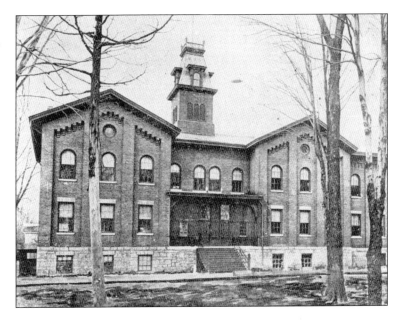

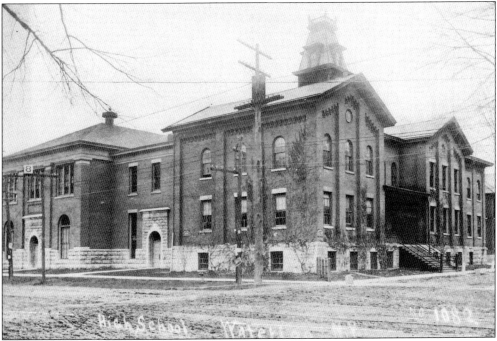

WATERLOO HIGH SCHOOL. The contract for building the new high school and assembly hall was awarded to Welling B. Lawrence and John Van Riper on April 19, 1901. It was a two-story brick and stone building adjoining the old school. The first floor was dedicated entirely to an assembly hall complete with dressing rooms and stage and the second floor to a study hall, three classrooms, and a library. The seats in the assembly hall came from the Johnstown Flood Exhibit at the Pan-American Exposition in Buffalo, New York.

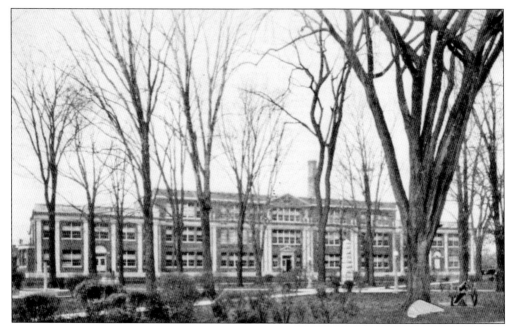

THE NEW HIGH SCHOOL BUILDING. In May 1927, the Union and high school buildings were declared too small and in need of numerous updates. By fall of 1928, the school had been demolished. Classes were held in a number of sites around town: the American Legion, the Waterloo Library and Historical Society, and St. Paul's Parish Home just to name a few. The new school was designed by Carl Ade, architect from Rochester, New York. This new building was opened for classes on September 3, 1929, with a formal opening on September 27, 1929. Engraved over the main entrance door is this phrase: "These doors are open to all who wish to learn."

WATERLOO HIGH SCHOOL, WATERLOO, N. Y.

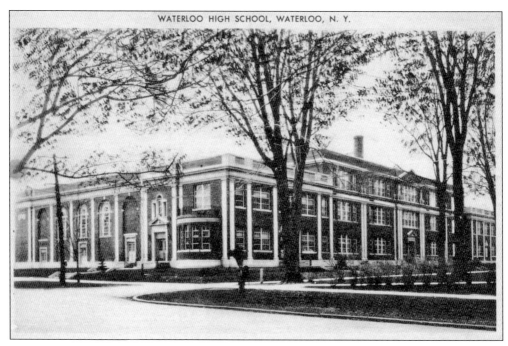

St. Mary's School, Center Street around 1935.

ST. MARY'S PAROCHIAL SCHOOL. In 1904, St. Mary's Church started a new parochial school in St. Mary's Hall and purchased a new nuns' residence. St. Mary's Parochial School opened for the first time on September 12, 1904, with about 100 students in attendance. Ground was broken for the new St. Mary's Parochial School on Center Street on April 10, 1910, with John Van Riper doing the mason work and Bert Barrett, the carpentry. The cornerstone of the school was laid on July 3, 1910.

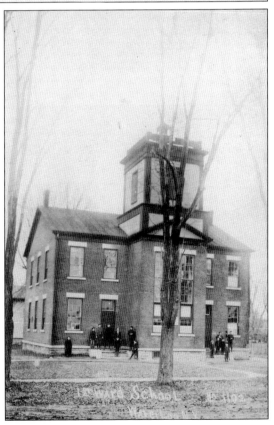

THE FIRST WARD PUBLIC SCHOOL. This school was located on River Street at the corner of Grove Street in South Waterloo. There was a Second Ward Public School located next to the Union School, but no photographs were available.

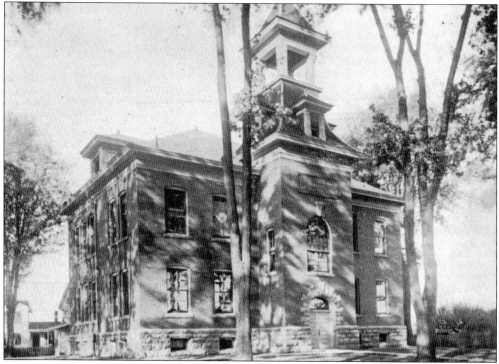

THIRD WARD PUBLIC SCHOOL. This school was located on Williams Street at the corner of Mills Street. The building is still standing and in use. At the annual meeting of the school district in 1853, it was decided that the entire expense for the school should be paid by taxation of the citizens. Thomas Fatzinger was the first tax collector. After a short time collecting the taxes, he concluded that it was easier to pay than to collect. With his check for the balance due, he canceled the tax due of his neighbors.

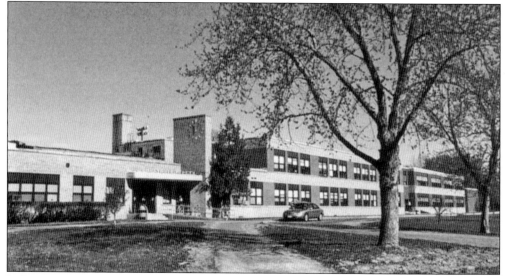

LAFAYETTE SCHOOL. Located on Inslee Street, this school was original built for elementary students but is now called LaFayette Intermediate School. It was built in the early 1950s and opened in 1952.

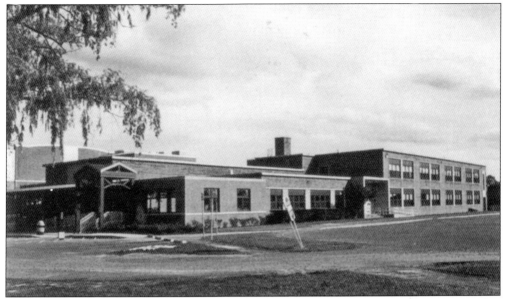

SKOI-YASE SCHOOL. Land for the building of this school located on Fayette Street was purchased in 1951, ground was broken later that year, and the cornerstone was laid in 1952. With construction completed, the school opened for classes in January 1953. Today, it is known as the Skoi-Yase Primary School. It is an elementary school.

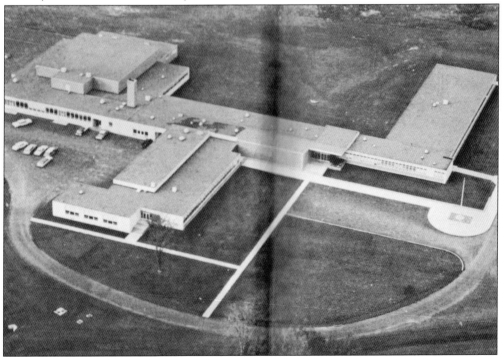

NEW WATERLOO SCHOOL CAMPUS. The new high school opened for classes in 1961. It was built to house grades 9 through 12. The class of 1965 was the first class to complete all four years in this school. It has been expanded and now houses the middle school (grades six through eight) and the high school. (Courtesy of the 1963 Waterloo High School Yearbook.)

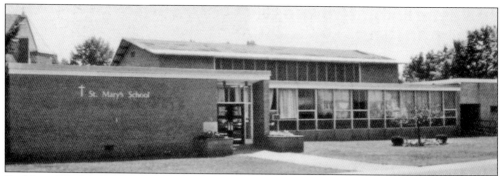

ST. MARY'S PAROCHIAL SCHOOL. The new St. Mary's School was built in 1960 and connected to the old school. It would house classrooms, offices, and a 340-seat combined cafeteria, auditorium, and classroom.

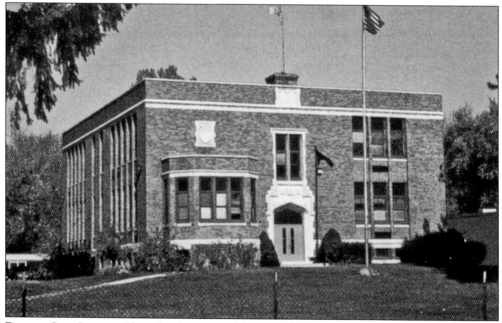

BORDER CITY SCHOOL. This school is a part of the Waterloo School District; however, it is located on Border City Road in the town of Geneva. It was a multiage school but is now considered an elementary school.

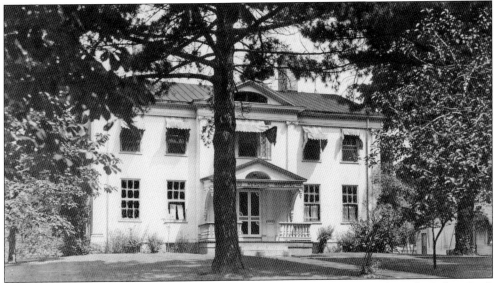

WATERLOO MEMORIAL HOSPITAL. This building was originally built as a residence by Ruben Swift for Elisha Williams. It was then purchased by Ruben Swift after Williams's death. Known as the Mansion House, it was built in 1815–1816 and located at 30 West Main Street. It was one of the best examples of the Federal style in as well as the first hospital in Waterloo. It opened in November 1920 and was dedicated to those soldiers, sailors, and marines of the towns of Waterloo, Junius, Fayette, and Varick who served in World War I. The hospital operated until 1958. (Courtesy of Diane Lerch Kurtz.)

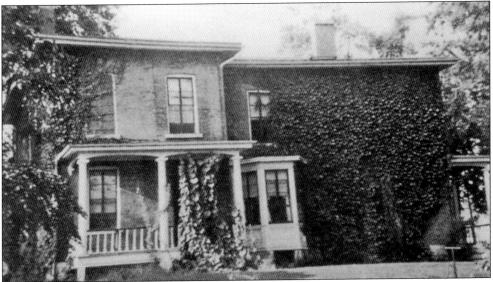

SENECA NURSING HOME. Fred and Hilda Houtenbrink purchased this former Waterloo mansion at 97 Center Street and converted it into the Seneca Nursing Home. They operated it as a nursing home from 1940 to 1966. In 1941, he converted the barn on the property to allow for Gay 90s–type dances. He also operated a chicken farm on the property for about five years, from 1941 to 1946. Today, the property is an apartment building. Fred established a tile and carpet business after closing the nursing home. His son Fritz went on to build that into a very successful business. (Courtesy of Fritz Houtenbrink.)

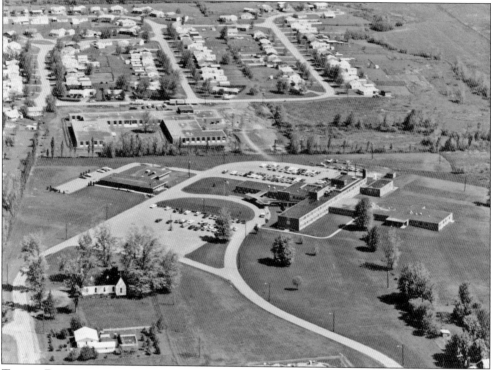

TAYLOR-BROWN MEMORIAL HOSPITAL. This new hospital, located on Routes 5 and 20 just outside of the village of Waterloo, became a reality through gifts and contributions from citizens and businesses in the area. Walter Klingbeil was instrumental in gathering support and funds for the building of this new facility. Ground-breaking was in 1957, and it was dedicated in October 1958 as a state-of-the-art facility. The hospital was named Taylor-Brown Memorial Hospital after Walter Klingbeil's mother, Grace Greenwood Taylor Klingbeil, and Dr. C. Anna Brown, founder of the Seneca Falls Hospital. (Below, courtesy of Diane Lerch Kurtz.)

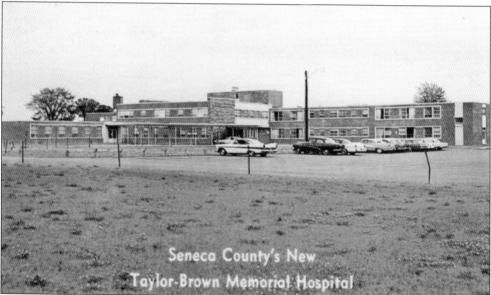

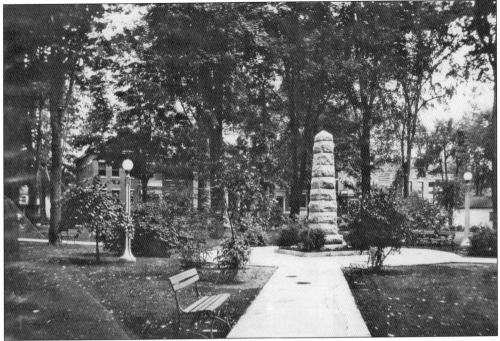

THE SULLIVAN CENTENNIAL AT THE PUBLIC SQUARE. In the center of the public square stands a stone monument called the Sullivan Monument. It was erected by the Waterloo Library and Historical Society in 1879 to mark the 100th anniversary of the Sullivan Expedition.

PUBLIC SQUARE. Charles A. Genung is the person primarily responsible for developing the park into the beautiful site it is. In 1908, he turned the area, overgrown with trees, into a beautiful park.

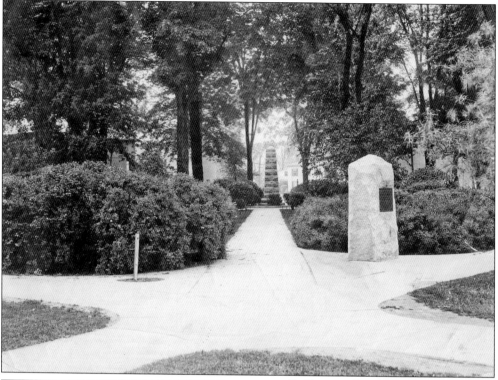

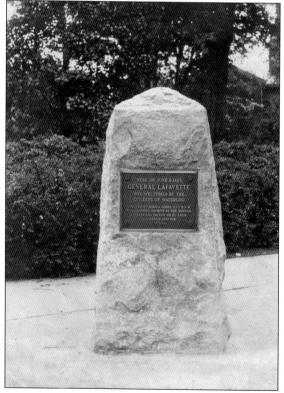

LaFayette Park. The Waterloo Library and Historical Society petitioned to change the name of the public square to LaFayette Park in 1921. The change went into effect on January 4, 1922. The Seneca Lodge No. 113, F&AM erected a monument to commemorate the visit of General LaFayette to Waterloo on June 8, 1825. The monument was placed in the park at the southeast corner, opposite the spot where almost 100 years ago General LaFayette was greeted by the people of Waterloo. June 8 became known as LaFayette Day. The Sullivan Monument is in the background.

Six

HOMES AND
STREET SCENES

Waterloo experienced fairly steady growth from 1820 to 1860. The population of the village increased from about 500 in 1820 to more than 3,300 in 1850. The original plan for Waterloo was designed to cover virtually all of Elisha Williams's 640-acre tract. The four corners area of Main Street and Virginia Street became the commercial district. After the Waterloo Woolen Mills were built, about five blocks east of the four corners, residential construction boomed. The village was incorporated in 1824, with most of the village north of Main Street filled in with streets, homes, churches, and other public buildings from 1820 to 1860.

The efforts of Elisha Williams and Ruben Swift to promote Waterloo and its location along the Seneca River and on the turnpike were the major factors contributing to the early growth of Waterloo. Early growth was due to the stagecoach traffic on the turnpike. As industry developed so did the village. According to early tradition, four streets were named after Elisha Williams and his family: Williams, Elisha, Elizabeth, and Virginia Streets. Swift Street was named after Ruben Swift.

The majority of the residences in Waterloo were constructed during this early period. Numerous houses were constructed in the Federal and Italianate styles. Many early homes were embellished with the Italianate style like the homes just east of the four corners, including the National Memorial Day Museum, which is listed in the National Register of Historic Places. Most of the homes built during this boom period still stand today.

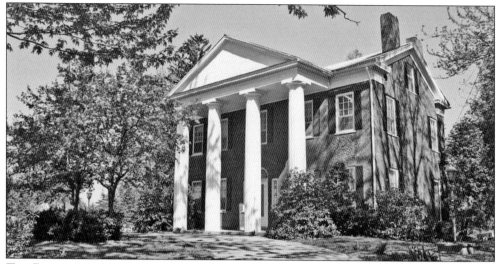

THE RICHARD P. HUNT HOMESTEAD. Hunt was the first secretary of the Waterloo Woolen Manufacturing Company. He was heavily invested in the company and one the largest land owners in the village. He built this home at the east end of Main Street on the farm that has been known as the Hunt farm for years. In 1848, Jane C. Hunt and four other women instituted the movement for women's rights and issued the call for the first Women's Rights Convention. Included in that meeting were Lucretia Mott, Elizabeth Cady Stanton, Martha C. Wright (Mott's sister), and Mary Ann M'Clintock. This home is listed in the National Register of Historic Places.

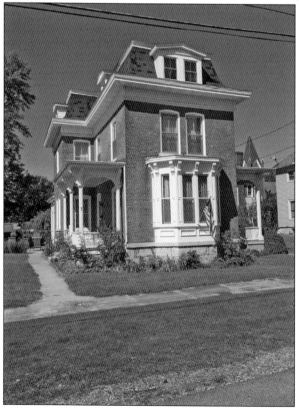

BURTON-SEMTNER RESIDENCE. This home was built by William H. Burton in 1870 for his son Edward as a wedding present. Edward died in 1890, and the home was sold to the Semtner family. Three generations of the family lived in the house until it was sold in 1962. (Author's collection.)

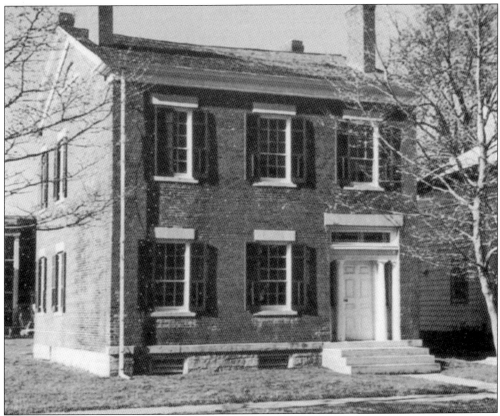

M'CLINTOCK RESIDENCE. This house is located at 14 East Williams Street and was the home of Thomas and Mary Ann M'Clintock. It is said that the Declaration of Sentiments adopted at the first Women's Rights Convention held in Seneca Falls, New York, was written here on the morning of July 14, 1848. This home is listed in the National Register of Historic Places.

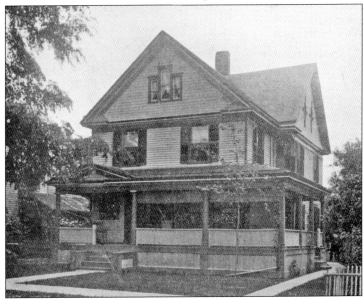

GREGORY RESIDENCE. This house, located on Church Street, is the former home of Isaac G. Gregory. Gregory owned one of the grocery stores in Waterloo in the late 1800s and early 1900s.

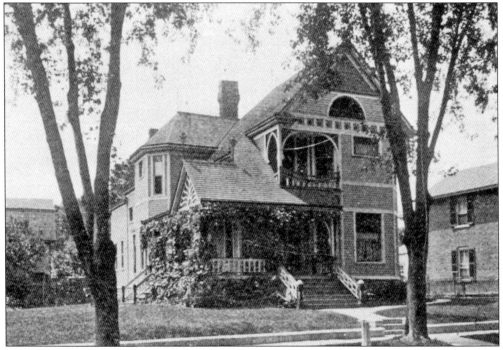

SCHOTT RESIDENCE. F.M. Schott was born in Waterloo on December 25, 1852. In 1877, he started a partnership with James Kelly under the name of Kelly & Schott to make and sell cigars; the business grew, and in 1900 James Kelly retired. Schott retained the business. He was an excellent judge of tobaccos, which accounted for the evenness in his cigars. The manufactory was located at 80 Virginia Street and the retail store next to it at 82 Virginia Street.

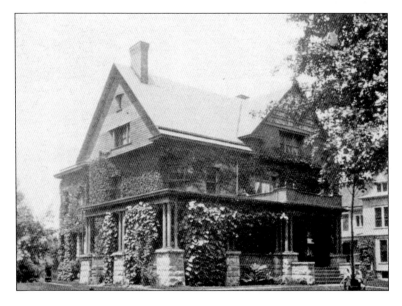

PIERSON RESIDENCE. This home located at 103 Virginia Street belonged to E.C. Pierson, who was in the nursery business. It was built in the 1890s.

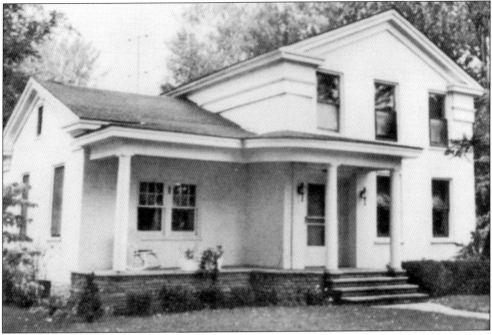

WELLS RESIDENCE. Located at 13 Center Street, this was the home of Henry C. Wells. He was instrumental in the founding of Decoration Day, or Memorial Day.

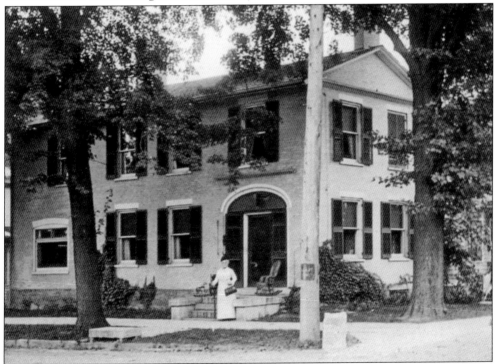

MURRAY RESIDENCE. This was the home of Gen. John B. Murray and is located at 111 West Main Street. Murray was instrumental in the development of a more complete Memorial Day observance.

MALONEY RESIDENCE. This was the home of Martin Maloney. He and his brother owned the Maloney Brothers Grocery Store on Main Street.

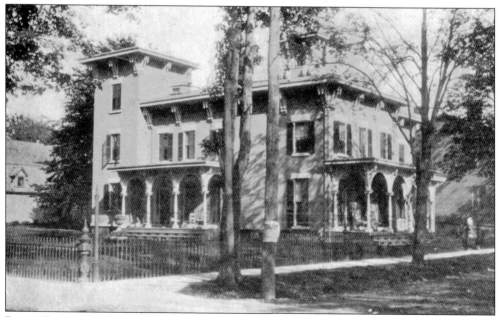

BACON RESIDENCE. Pictured here in the 1930s is the Virginia Street home of Francis W. Bacon.

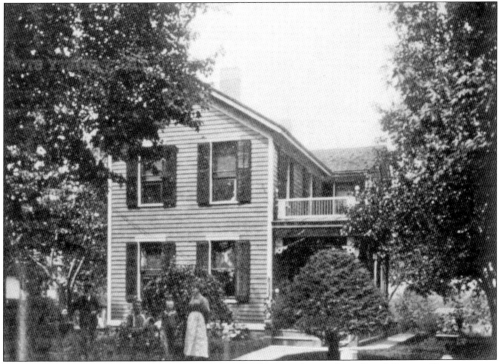

GRAVES RESIDENCE. The George W. Graves residence is located on Reed Street. Graves was a veteran of the Civil War who enlisted in the 21st New York Volunteer Cavalry.

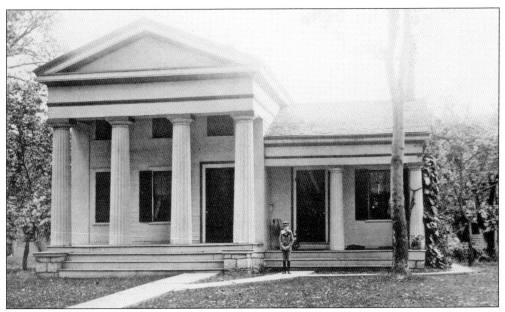

KNIGHT RESIDENCE. This home was the residence of Benajah B. Knight. Knight purchased the first piano manufactured by Waterloo Piano Company. His son William D. Knight gave the piano to the Waterloo Library and Historical Society, where it is on display.

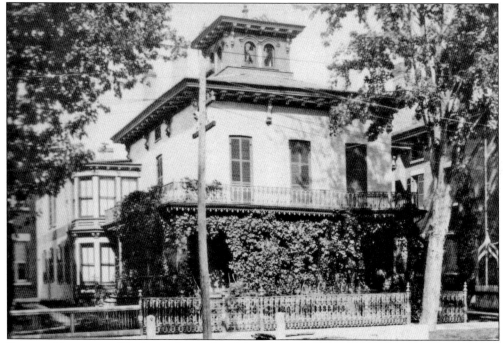

BURTON RESIDENCE. This home located on Main Street belonged to William H. Burton. This home is now the National Memorial Day Museum.

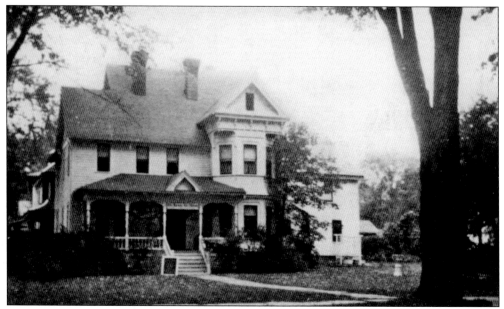

BARNES TEA ROOM. This was the home of Gladys Barnes in the 1920s. She ran a very proper tea room at this residence, 45 Virginia Street. A number of families owned this property, including Dr. William Magenheimer.

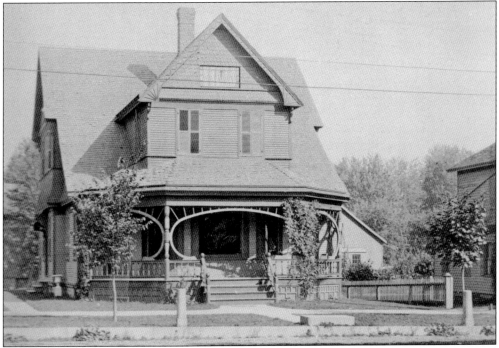

GENUNG OFFICE AND RESIDENCE. This home and office has been and is the Genung Funeral Home. It is pictured here in the 1930s under the ownership of Seth J. Genung. The family also resided here.

LAWRENCE RESIDENCE. Located on Main Street near the intersection of Oak Street was the home of Welling B. Lawrence. He was a builder and built this house.

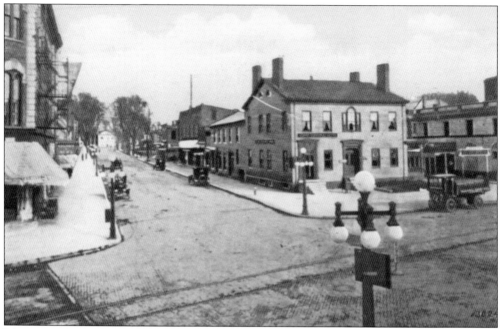

MAIN STREET. This is the corner of Main Street and Virginia Street. The first National Bank of Waterloo is on the right.

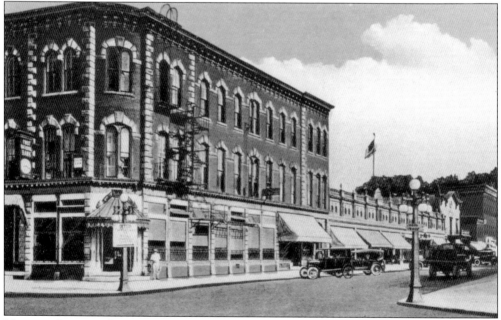

VIRGINIA STREET. This is the Towsley House, a very fine hotel. It was located on the northwest corner of Virginia and Main Streets.

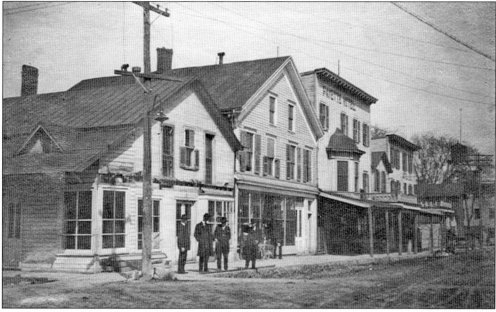

WASHINGTON STREET. Pictured here in 1913 are shops along Washington Street, including the Fayette Hotel. Most of the buildings on the west side of Washington Street were demolished when contractors began work on the barge canal.

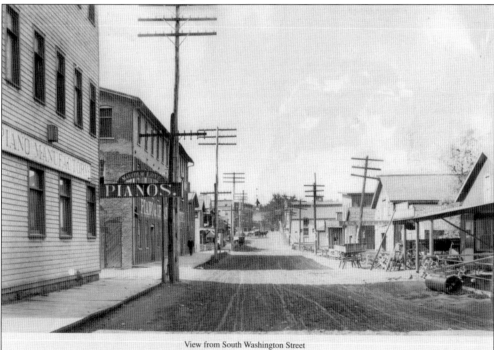

View from South Washington Street

SOUTH WASHINGTON. Looking north on Washington Street, on the left, or the west side, is the new three-story wood-frame factory built on the William W. Wood mill site in 1897. This factory, built by Welling B Lawrence, was used to manufacture the Malcolm Love piano. Just north of this factory is the Waterloo Organ Company. (Courtesy of the Terwilliger Museum.)

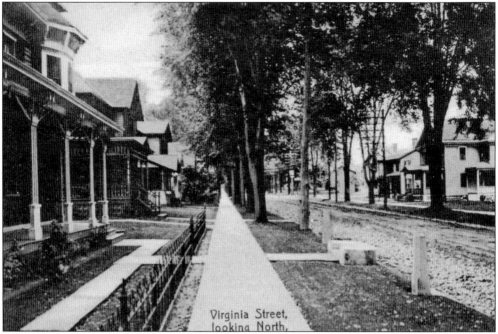

VIRGINIA STREET. This image, looking north on Virginia Street from Elizabeth Street, was taken prior to the paving of Virginia Street in 1916. Virginia Street is the most picturesque thoroughfare in Waterloo.

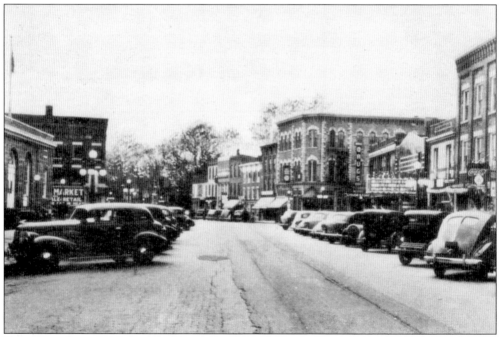

EAST MAIN STREET. This view of East Main Street looks west from just east of the post office in the late 1930s. The first building on the left, just beyond the post office, is Lux's Market. On the other side of the street is the State Theater, a drugstore, and the First National Bank of Waterloo (formerly the Towsley House).

100

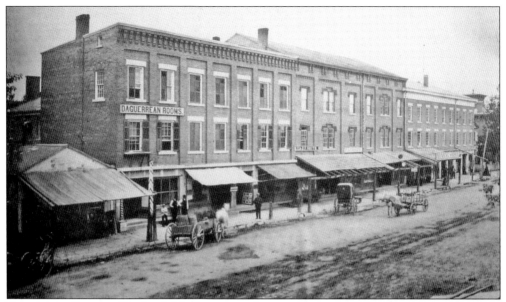

EAST MAIN STREET. The brick block to the right was the first to be built (Semtner Block) by Richard P. Hunt in 1839, the middle block (Odd Fellows Block) was the second, completed in the 1840s. He built the third block (Mazzoli Block) in 1856–1858. This made a continuous brick block containing nine stores. The printing office and the Thomas M'Clintock drug and book store were in the Semtner Block, the grocery and provisions store of H.E. and H.F. Smith was in the Odd Fellows Block, and Daguerrean had rooms to rent in the Mazzoli Block.

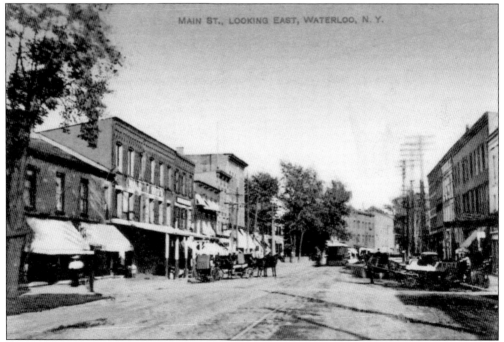

WEST MAIN STREET. This image, taken in the late 1800s, is looking east on West Main Street. On the left, the three-story building is the Maloney Brothers Grocery Store. Horse and buggies were still in use, as was the trolley coming down the center of Main Street.

WEST MAIN STREET. The image was taken in the late 1800s from West Main Street looking east. This shows the shops that were closer to the intersection of Main and Virginia Streets. The hardware store is on the right, and a café is just beyond. A bicycle rider is coming down the center of the street followed by the trolley.

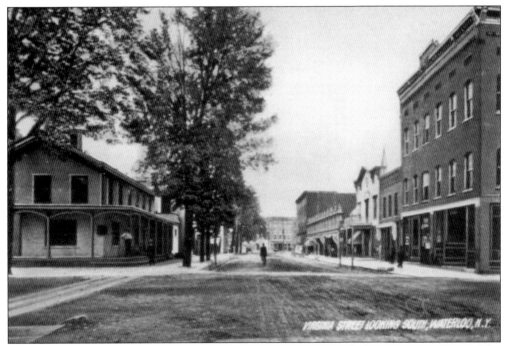

VIRGINIA STREET. This view is from Williams Street looking south down Virginia Street. The building on the left is the Brunswick Hotel. (Courtesy of Diane Lerch Kurtz.)

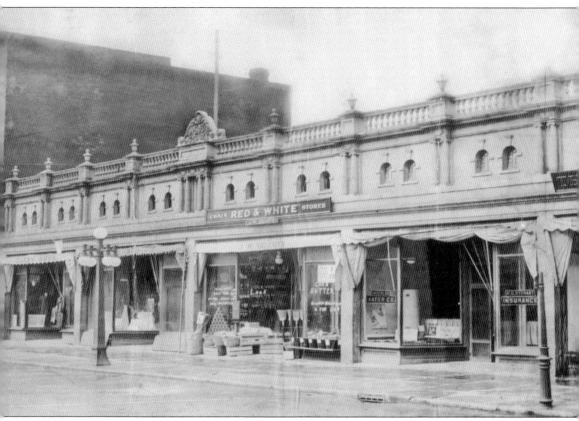

VIRGINIA STREET. Pictured here are the businesses along the west side of Virginia Street around 1935. The Red & White Grocery Store is in the center. (Courtesy of the Terwilliger Museum.)

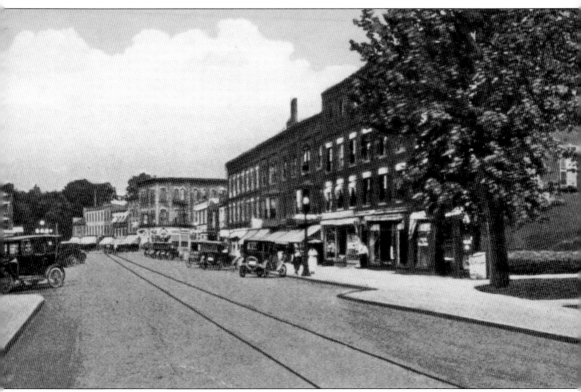

EAST MAIN STREET. This is a more modern view of East Main Street looking west in the 1920s, shortly after the paving of Main Street. The three brick blocks on the right are still standing today. Most vehicles in the image are 1920s Model Ts.

Seven

PEOPLE AND PLACES

The citizens of Waterloo have worked continuously to build a wonderful community environment for everyone living in or visiting this village. It is evident by the number of impressive public buildings and private homes that still stand, many built in the late 1800s. Many are listed in the National Register of Historic Places.

Numerous people from Waterloo have risen to the top in many different fields, from sports to government service. Tom Coughlin, Commander Sweet, and Louise Scherbyn were from Waterloo. Many people have become inventors or accomplished firsts in their field, people like Barney Oldfield, Wellington Porter, Mary Ann M'Clintock, and Jane Hunt.

Waterloo is credited with being not only the Birthplace of Memorial Day but also home to the start of the women's rights movement.

Waterloo had a number of firsts, even in the very early days of development. In the middle of the 1800s, it was the largest town in western New York State. It grew very quickly from a population of 300 in 1820 to 3,300 in 1850.

GENUNG AND HIS AUTOS. Charles A. Genung is shown here with his 1917 Hudson Sedan Super Six and 1915 Hudson Touring Car. Genung was an undertaker and developed a method of embalming. He embalmed the body of George "Bill" Bailey in 1899, a local farm hand who had died with no close relatives. The body was available for viewing at the Genung Funeral Home on Main Street until 1971—72 years and four months after Bailey died. Charles's grandson John S. Genung made the decision to give him a respectful funeral and burial.

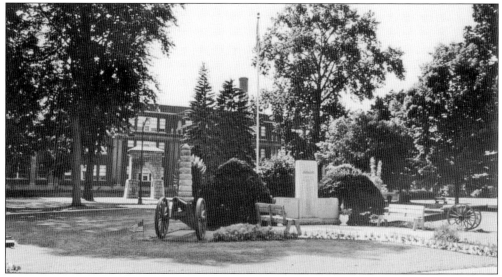

CANNONS IN THE PARK. At the request of Francis Bacon, Congress introduced a bill authorizing the secretary of war to "donate and deliver the Village of Waterloo, two condemned bronze or brass cannons or field pieces and carriages, together with a suitable number of cannon balls for pyramids." They were placed in LaFayette Park. Charles A. Genung was determined to remove what he thought was one solid iron ball that appeared to be stuck in the mouth of one of the cannons. He put a small amount of gunpowder into the cannon, inserted the fuse, and touched off the cannon. The small amount of powder proved to be of great enough strength to fire the three balls in the cannon, each striking a building: the Genung residence, the Bacon residence, and Bertino's Hotel on Washington Street. No one was injured, but Genung was kidded for years.

MARY ANN M'CLINTOCK (RIGHT) AND JANE HUNT (BELOW). These two women, together with Elizabeth Cady Stanton, Lucretia Mott, and Martha Wright, were responsible for the idea and development of the first Women's Rights Convention. The idea was conceived in Waterloo at the home of Richard P. and Jane Hunt. They wrote the Declaration of Sentiments at the home of Mary Ann M'Clintock, in which they listed 18 grievances under which women felt themselves oppressed and fraudulently deprived of their most sacred rights. At their first meeting on July 13, 1848, they decided to call for a Women's Rights Convention to be held in five days. Susan B. Anthony and Amelia Bloomer joined the group. These women are largely responsible for the rights that all American women enjoy today. The Hunt and M'Clintock houses are included in the Women's Rights National Historical Park, part of the National Park Service.

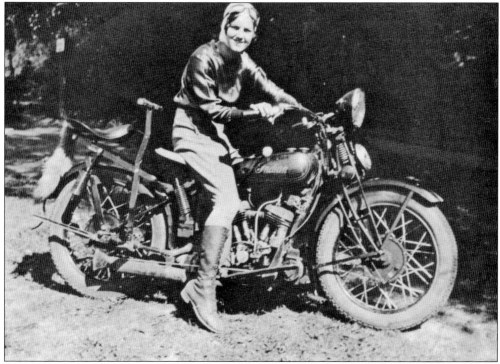

LOUISE SCHERBYN. Scherbyn was inducted into the Indian Motorcycle Museum Hall of Fame in 1988. She received her first Indian motorcycle from her husband, a 1932. She traveled all over the United States and Canada, becoming the first woman to reach the far north, the Temagami Forest of Canada in 1937. In 1950, she founded the Women's International Motorcycle Association. She owned three Indians and always carried her lucky rabbit's foot. She never had an accident in her 225,000 miles of riding. Scherbyn lived in Waterloo on East Main Street.

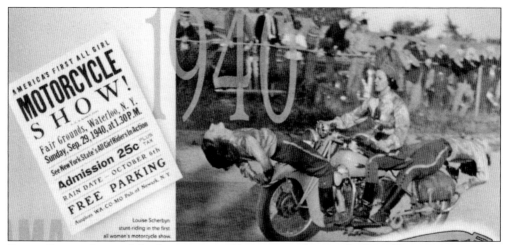

STUNT RIDING. Louise Scherbyn is pictured here stunt riding in the first all-women motorcycle show held in 1940 at the fairgrounds in Waterloo.

BARNEY OLDFIELD. Andrew H. "Barney" Oldfield really got around, usually in a device he invented. He designed a miniature motorcycle called the Barney Bike in the 1940s. He also produced the rear-drive Oldfield motorcycle by combining a two-cylinder Zundapp motorcycle engine, transmission, and shaft drive with the frame of a 1940 Indian Scout. (Courtesy of Kathleen Oldfield and the Waterloo Library and Historical Society.)

BABY LAKES. Oldfield also built a snappy little Baby Lakes Airplane. The biplane has a wingspan of 12 feet and transports one person efficiently and inexpensively. Plans are still available today. (Courtesy of Kathleen Oldfield and the Waterloo Library and Historical Society.)

CORN SHELLER. William D. Burrall designed and made this corn sheller, which was first patented in 1863. It is still in use today. He made the shellers in Waterloo and then licensed the manufacture to other localities.

NEW BICYCLE. On September 6, 1898, Louis Burgess of Waterloo received a patent for a propelling mechanism for bicycles. It was the beginning of the chain-drive bicycles. (Courtesy of Darlene Duprey and the Waterloo Library and Historical Society.)

TIMBER HARVESTER. Sawing wood is the job of this timber harvester designed and built by the Nelson family of Waterloo. They began building portable-band sawmills in 1989. They have continued to improve efficiency and production with the development of their products.

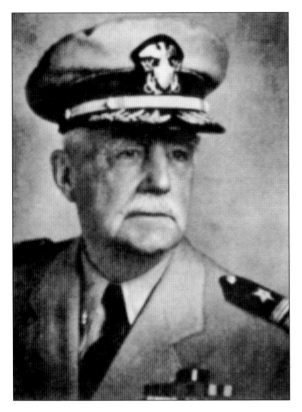

COMMANDER SWEET. In 1907, Lt. George C. Sweet, USN, was named the first member of the Joint Services Aeronautical Board. In 1908, he became the first US Naval representative to fly. He also flew with the Wright brothers in Kitty Hawk. His home in Waterloo was used as the VFW until it was destroyed by fire.

Thomas R. Coughlin

"Ernie"

Basketball 1,2,3,4; Football 2, 3,4; Dance Committee 2,3,4; King of Junior Prom; Baseball 1,2,3, 4; Varsity Club 2,3,4, Tres. 3,4

TOM COUGHLIN. Coughlin, born in Waterloo, is the current head coach for the New York Giants Football Team. He has led the Giants to two Super Bowl victories and was the inaugural head coach for the Jacksonville Jaguars. He has been head coach of the Boston College Eagles and served in a number of other coaching positions. He is a graduate of Waterloo High School and Syracuse University. This is his 1964 senior high school yearbook portrait.

MAPLE GROVE SPEEDWAY. Racing at Maple Grove had stopped by the late 1930s, but in 1953 it started all over again. The Waterloo Stock Car Racing Association was formed and held their first race on October 2, 1953. For the next 24 years (except for three years in the 1970s), WSCRA promoted racing at the Maple Grove Speedway.

DIRT MODIFIED. By the 1960s, racing became so expensive many could not afford to build a car. The WSCRA came up with a late-model division. This car built by Weldon Lawrence and driven by John Birosh (both from Waterloo) raced at Waterloo. It is a 1949 Ford dirt late model. Mike "Magic Shoes" McLaughlin, Walt Mitchell, Rollie Velte, and Ron Narducci also (from Waterloo) raced here. Birosh went on to race modified and super sprints, then to crew chief for a NASCAR Busch team in North Carolina. McLaughlin went on to drive for a Busch North team then to NASCAR Busch team. (Courtesy of Greg Birosh.)

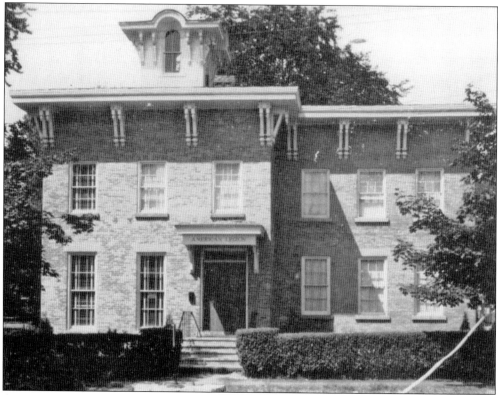

AMERICAN LEGION HOME, WARNER-VAN RIPER POST, POST NO. 435. This home was the former residence of Joseph Wright, remodeled in 1947–1948. The post was named for two Waterloo boys: Floyd C. Warner, a member of the Machine Gun Battalion 306, was killed in action at the battle of Flemmes in 1918, and Cpl. Thomas Van Riper served in Company B, 108th Infantry and died in a hospital in France after storming the Hindenburg Line on October 6, 1918. The Department of New York American Legion, Inc. purchased its present home on the northeast corner of Virginia and Williams Street. Its charter is dated January 2, 1920.

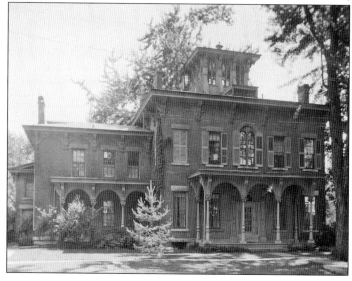

VETERANS OF FOREIGN WARS. VFW Post No. 6433 was originally started in rented rooms in the Gay's Commercial Clock. They were chartered in 1946. They purchased the building shown here, which was the residence of Comdr. George C. Sweet, on West Elisha Street. It was destroyed by fire in 1948. The VFW raised funds to build a new facility on the same site. That building stands today as the VFW Post No. 6433.

SENECA COUNTY CLERK'S OFFICE.
Shown here about 1896, this building was authorized in 1858–1859 and completed in 1861. It was located on the east side of Virginia Street and served as the county clerk's office part of the time until 1900, when the building sold and a new building was built next to the courthouse and the jail.

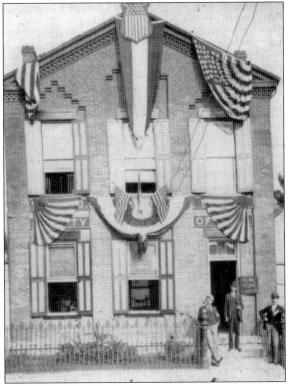

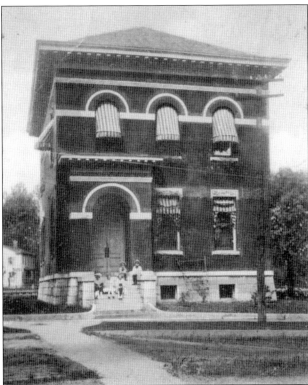

NEW CLERK'S OFFICE. The former Seneca County Clerk's office building was located on Virginia Street, when in 1901 plans were approved to build a new fireproof building with a basement. The first floor was devoted to the county clerk, the south end of the second floor was for the surrogate and county judge, and the room to the north was for the board of supervisors. Welling B. Lawrence and John Van Riper were awarded the contract to build the new structure.

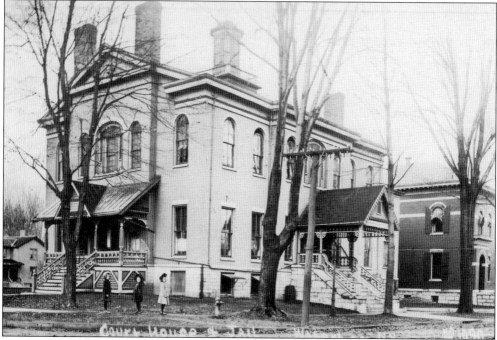

SENECA COUNTY COURT HOUSE. The Seneca County Court House and Jail were both enclosed in this same building. The structure was completed in 1818, and courts were held in it that year. The site was conveyed to the county by Elisha Williams. The county clerk's office is visible on the right.

A PICTURESQUE VIEW OF COUNTY BUILDINGS FROM THE PARK, WATERLOO, N. Y.

SENECA COUNTY BUILDINGS. In February 1914, it was decided by the board of supervisors to remodel the courthouse in Waterloo. They dismantled the jail and constructed a modern jail east of the county clerk's office. They also constructed a fireproof building for the safekeeping of the county records. The new jail, sheriff's office, and county clerk's office were opened in July 1915.

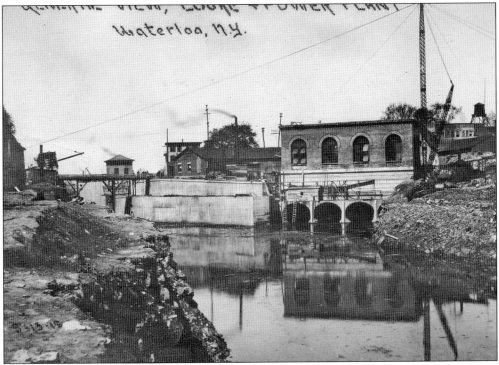

NEW CONSTRUCTION. This provides a general view of the construction of Lock No. 4 on the left and the power plant on the right in 1914. Both structures exist today, with the American Civil War Memorial on the land between the two. This memorial pays tribute to the sacrifice made by the citizens of Waterloo during the Civil War. These structures are located just south of the four corners on Washington Street. The power plant is on the east, and Lock No. 4 is on the west side of the street.

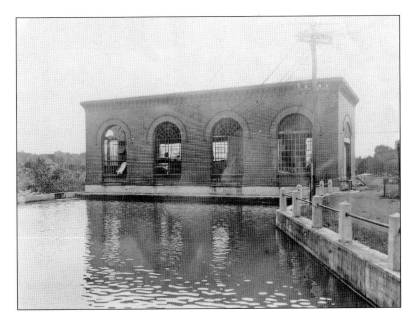

POWER PLANT. Pictured here is the completed power plant on the Seneca River.

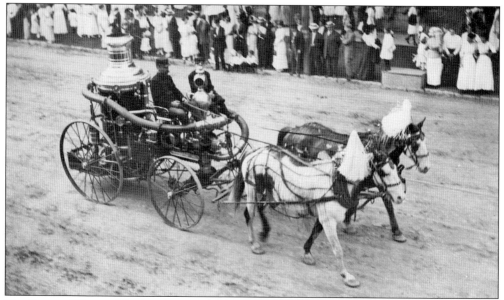

THE PARADE WAGON. This handsome wagon was used by the fire departments as a parade carriage. It is pictured here during a Firemen's Parade in the early 1900s. The carriage with the service cart was kept in their hose house on Main Street.

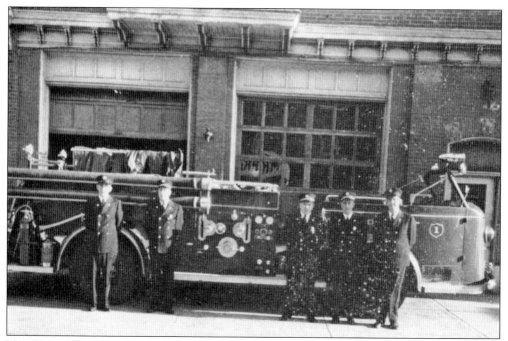

NEW PUMP WAGON. Officers of the Waterloo Fire Department in 1948 are pictured here standing in front of the new pumper. From left to right are Arthur Jensen (captain), George F. Chappelle (second assistant chief), Norman Comiskey (chief), George F. Jarvis (first assistant chief), and Earl H. Lahr (lieutenant).

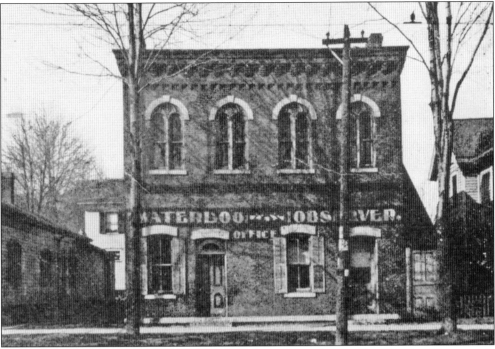

WATERLOO OBSERVER. This building is located on East Main Street. The *Waterloo Observer* was the oldest paper published in Seneca County. Their first issue was in 1826, and they continued to provide news to the area through 1961. The newspaper has had many different owners and editors during its 100-plus years of business. It was always known as being the best equipped newspaper and printing office in Seneca County.

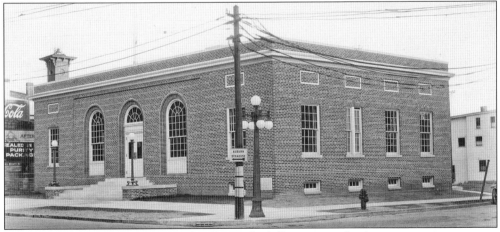

POST OFFICE. Pres. William Howard Taft signed a bill approving funds to construct a new post office in Waterloo on the southeast corner of Main and Virginia Streets. Congress had appropriated $10,000, but it was not enough. Townspeople tried to raise additional funds. In June, Congress approved additional funds amounting to $11,000. The village was now able to purchase the property, and the Waterloo Post Office became a postal savings depository on September 22, 1911. It was originally designed as a two-story building but was cut down to one story. The architect was James A. Wetmore. It was dedicated on August 29, 1925, and is listed in the National Register of Historic Places.

ICE SKATING. Pictured here on January 19, 1916, is the skating rink located between Seneca and Oak Streets. In the 1950s and 1960s, ice skating was enjoyed at the village rink at the corner of Elizabeth and Swift Streets.

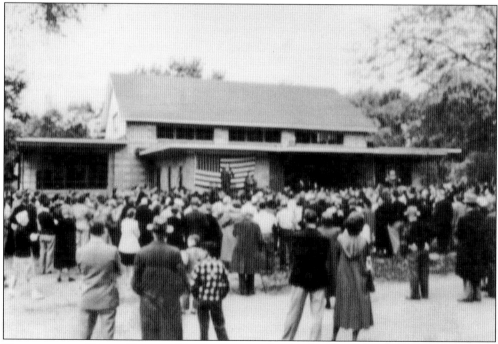

DEDICATION OF YOUTH CENTER. The cornerstone for this building, the recreation center, was laid in September 1948. An open house was held January 31, and by March they were holding community meetings there. This is the dedication on October 6, 1949, with approximately 1,500 people in attendance. Gov. Thomas E. Dewey joined the group for the dedication, saying, "I dedicate this new building to the welfare of the young people of Waterloo and to their everlasting right to grow up in a country where they can be free and envelop happiness. This building is a movement toward the kind of freedom in this country that I believe is essential, and without it, I feel we would not survive as a nation."

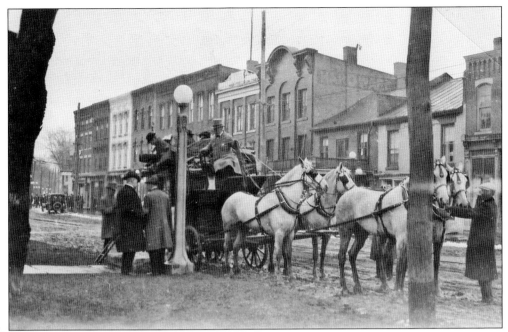

LIBERTY COACH. This coach was built in 1893 by James G. Bennett after the design of the old London Mall. The coach was drawn by four favorite grays of Margaret Vanderbilt. She is the widow of Alfred G. Vanderbilt, who lost his life on the *Lusitania*. The coach would visit 84 cities and towns on a 29-day trip in the interest of the third liberty loan to help win the war. One stop, on April 12, 1910, was in Waterloo, where Vanderbilt was met with refreshments, speeches, a meeting, and a number of citizens to support the cause.

RAILROAD DEPOT. The New York Central Rail Road Depot is located just east of Virginia Street. In 1876, this new depot was built a little farther east than the original depot.

SCYTHE TREE. Located on a farm just west of the village of Waterloo is this historic balm of Gilead. It is a species rarely found in this area. In 1861, Wyman J. Johnson hung his scythe in this tree, telling his mother to leave it there until he returned from the war, but he never returned. In 1918, the Schaffer brothers left their scythes in the same tree before leaving to go to war. During the war, three flags flew for the three men. The Schaffer brothers returned, and today only one flag flies, for Johnson. The tree is listed in the Hall of Fame in Washington, DC, and stands today as a living monument, chosen as one of the nation's 12 most famous trees. (Courtesy of Diane Lerch Kurtz.)

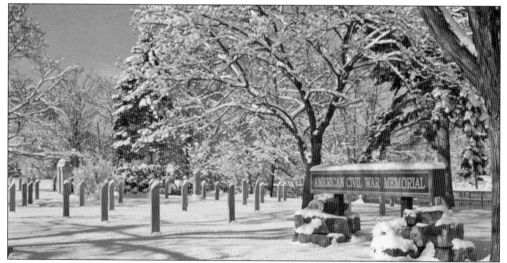

NEW CIVIL WAR MEMORIAL. Located just south of Main Street on Washington Street, this American Civil War Memorial pays tribute to the sacrifices made by the citizens of Waterloo during the Civil War. It also recognizes the soldiers from the North and the South who gave their lives in the war.

125 MILES EAST OF NIAGARA FALLS, N. Y. ROUTES 5 AND 20 53-30

WINDMILL. This windmill is located on Routes 5 and 20 between Waterloo and Seneca Falls. It was a tea room and service station as well as a tourist camp, complete with cottages.

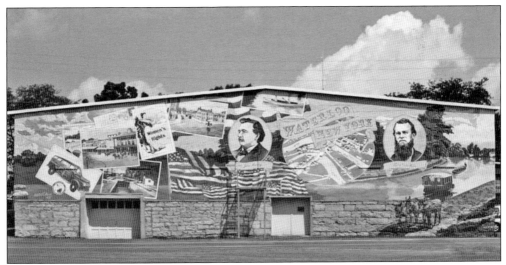

VERN'S WAY. Images of Waterloo's history cover the back of the village office building off Virginia Street. The mural was painted for the 2007 Memorial Day Celebration by artist David Serotkin and introduces visitors to some of the history of this quaint village. Vern's Way is the name of the short drive to this site. (Author's collection.)

ROSARY MOUND IN ST. MARY'S CEMETERY. In 1887, St. Mary's Cemetery was started on a six-acre piece of land with 480 lots. The first monument erected in the cemetery was in memory of Cathrine Roden Morrin (wife of William Morrin) in September 1888. The cemetery was dedicated in November 1888 by Bishop McQuaid of Rochester, New York. The Rosary Mound, which was eight years in the making and took exactly nine months to design and construct, was conceived by Louis LeBrun. LeBrun and Don Dwello, along with many other members of the church, created this stone altar, surrounded by an eight-inch granite curb featuring four-inch solid brass beads forming the rosary. It includes a 10.5-foot crucifix flanked by five-foot-tall figures of the Virgin Mary and St. John. The Rosary Mound was dedicated to Fr. Albert Shamon on September 8, 1985, by Bishop Matthew Clark.

MAPLE GROVE CEMETERY. In 1849, at a public meeting, it was voted to purchase land for a new cemetery. The town purchased about four acres on the corner of Stark Street and what was then North Street. This became Maple Grove Cemetery. Over the years, additional land has been purchased on several occasions to increase the size of the cemetery. Ruben Swift's son was the first to be buried in the old part of the cemetery, and it is believed that Charles Inslee was the first to be buried in the new part.

Eight

WATERLOO LIBRARY AND HISTORICAL SOCIETY

The library was first organized as the Waterloo Historical Society, then as the Waterloo Literary and Historical Society, and finally as the Waterloo Library and Historical Society and was incorporated in 1875 with this name.

Thomas Fatzinger gave $5,000 as a foundation to establish the library. He gave an additional $1,000 in 1877 to meet immediate needs, and in 1878 he gave $250 to promote general interest and defray current expenses. When Thomas Fatzinger died in April 1878, he left in his will a legacy of $5,000 for the library.

The land it is built on was given by Dr. S.R. Wells in 1878, and the lot adjacent to it was given by Mrs. Francis P. (Hoskins) Fatzinger in 1879. Plans were approved, and the contract for building was given to John Emmett of Waterloo and A.B. Morrison of Geneva for $10,865. The structure was to be completed by June 1, 1881.

The laying of the cornerstone of the Waterloo Library and Historical Society took place on September 28, 1880. The vice president of the society, Walter Quinby, placed various papers and articles in a box to be placed in the cornerstone.

The first book was drawn from the library on December 8, 1883.

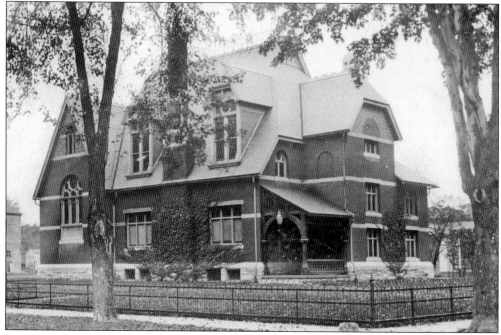

WATERLOO LIBRARY AND HISTORICAL SOCIETY. The Waterloo Library was founded in 1875. This building was designed by architects Nichols & Brown of Albany, New York, in the Queen Anne Victorian Style. In 1878, Dr. S.R. Wells donated the lot on the corner of Williams and Church Streets for the sight of the library. In 1879, Mrs. Thomas Fatzinger gave a lot on Church Street, adjacent to the site given by Dr. Wells, and $1,000 toward the erection of the library. In 1879, plans for the library building were presented by Mrs. Fatzinger and accepted by the board of trustees. Pictured here in 1910, the building is located at 31 Williams Street and is listed in the National Register of Historic Places.

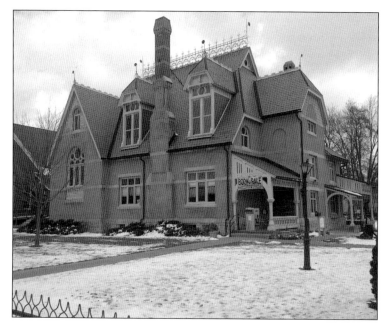

WATERLOO LIBRARY AND HISTORICAL SOCIETY TODAY. The iron fence around the society's property was constructed by the Waterloo Wrought Iron Fence Company. It remains in place today. The second floor of the library plays host to a number of events, including music recitals, speeches and civic gatherings, plays, lectures, children's programs, and weddings. (Author's collection.)

126

THE TERWILLIGER MUSEUM, OR TERWILLIGER HALL. This addition to the Waterloo Library and Historical Society was opened in 1960 and named for Charles P. Terwilliger, who willed money for the development of the museum. It houses numerous collections of local history, from Indian artifacts to antique automobiles. It also contains five period rooms, from a log cabin to the Roaring Twenties. (Author's collection.)

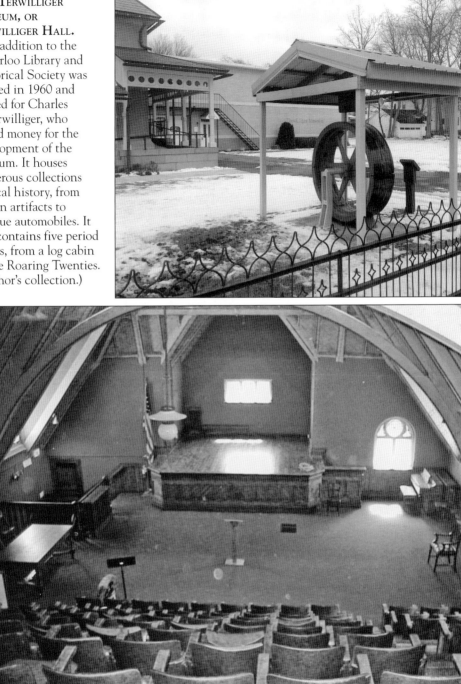

FATZINGER HALL. The second floor of the library building houses what was called a performance hall. It has a raised stage and tiered seating for 150 people. It was a unique design for the time period because it was a large open space with no supporting posts. The room was named after the prominent businessman Thomas Fatzinger. Fire regulations closed the hall in the late 1920s, but it was reopened in the 1970s after a second exit and fire escape were added.

DISCOVER THOUSANDS OF LOCAL HISTORY BOOKS FEATURING MILLIONS OF VINTAGE IMAGES

Arcadia Publishing, the leading local history publisher in the United States, is committed to making history accessible and meaningful through publishing books that celebrate and preserve the heritage of America's people and places.

Find more books like this at
www.arcadiapublishing.com

Search for your hometown history, your old stomping grounds, and even your favorite sports team.

Consistent with our mission to preserve history on a local level, this book was printed in South Carolina on American-made paper and manufactured entirely in the United States. Products carrying the accredited Forest Stewardship Council (FSC) label are printed on 100 percent FSC-certified paper.

MADE IN THE
USA